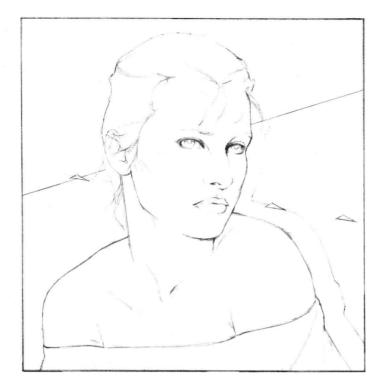

The Art of Patrick Nagel

ALFRED VAN DER MARCK EDITIONS•NEW YORK

Editorial Director: Robert Walter
Editor: Jeffrey Book
Designer: Stephen Meltzer

Library of Congress Cataloging-in-Publication Data
Nagel, Patrick, 1945-1984.
 Nagel: the art of Patrick Nagel.

 I. Nagel, Patrick, 1945-1984 – Catalogs. I. Title.
II. Title: Art of Patrick Nagel.
N6537.N33A4 1985 760'.092'4 85-40036

ISBN 0-912383-36-4
ISBN 0-912383-11-9 (hardcover edition)
ISBN 0-912383-21-6 (slipcased edition)

Printed in Italy by Poligrafiche Bolis, Bergamo
Typography: Andresen Typographics, Tucson, AZ
Color Separations: TH Graphics, Walnut, CA

First paperbound edition: July 1987

Patrick Nagel
1945-1984

Foreword/Elena G. Millie:

At any time there are a few who give form and meaning to their generation. Patrick Nagel's emergence as one of these gifted few stemmed from his unique vision of the contemporary woman: She is elegant and sophisticated, exuding an air of mysterious enticement. She is capable, alluring, and graceful, but also aloof and distant. You will never know this woman, though she stares out of the Nagel frame straight at you, compelling you to become more involved, challenging you to an intense confrontation.

Nagel has created one of the most successful paintings and graphics series to appear in the last two decades. The Nagel woman has enjoyed an astounding success, both in America and abroad. His work, which bridges the gap between traditional fine art and contemporary trends, has achieved an almost unprecedented popularity.

Patrick Nagel's bright and promising career ended with his death in February 1984, at the age of thirty-eight. I first became aware of Patrick Nagel's work in 1979. A friend gave me a poster she had commissioned Nagel to design for her gallery in New York. I was so taken with his craftsmanship that I immediately contacted Mirage Editions, publishers of the Nagel graphics, in order to acquire more of them for the Library of Congress collection. Later that year I included that first poster I had seen—*Park South Gallery at Carnegie Hall*—as well as his poster *The Paper Mill* (for the Los Angeles firm of the same name) in a major poster exhibit at the Library of Congress. These posters were a breath of fresh air after the torrent of psychedelic and propaganda posters that had flooded the scene in the late 1960s and in the 1970s.

From the initial publication of the first Nagel woman, an intensely loyal following developed that snapped up each succeeding edition immediately upon, or even prior to, publication. His creations include more than sixty graphics editions and posters, plus commemorative editions, as well as commissions by *Architectural Digest* and *Playboy,* and a 1983 record cover for a Duran Duran album that became the number-one album in the world. In addition, he did many magazine covers and illustrations. His work for *Playboy,* particularly, helped build his reputation by increasing his recognition and popularity.

Nagel also created many series of posters for larger distribution. Poster art is one of the most influential and pervasive of all the arts. In cities, posters meet the eye at every turn. They appeal, persuade, arouse, entice. In America, where posters have not consistently maintained the high artistic standards adhered to in some other countries, Patrick Nagel's posters stand out.

Like some of the old print masters (Toulouse-Lautrec and Bonnard, for example), Nagel was influenced by the Japanese woodblock print, with figures silhouetted against a neutral background, with strong areas of black and white, and with bold line and unusual angles of view. He handled colors with rare originality and freedom; he forced perspective from flat, two-dimensional images; and he kept simplifying, working to get more across with fewer elements. His simple and precise imagery is also reminiscent of the art-deco style of the 1920s and 1930s—its sharp linear treatment, geometric simplicity, and stylization of form yield images that are formal yet decorative.

Nagel was given a free hand in designing his graphics. His preliminary drawings for these designs are the exact antithesis of the final paintings. They are light, airy, ragged, and free. They are composed by line, but not confined by line. He would submit images for the client to choose from, subtly suggesting the product in the artwork. After the choice had been made, Nagel would then work up the finished painting, choosing the colors and lettering himself. He sometimes

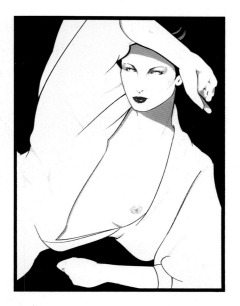

Untitled
Acrylic on board
Playboy illustration

opposite page:
Untitled
Acrylic on board
Playboy illustration

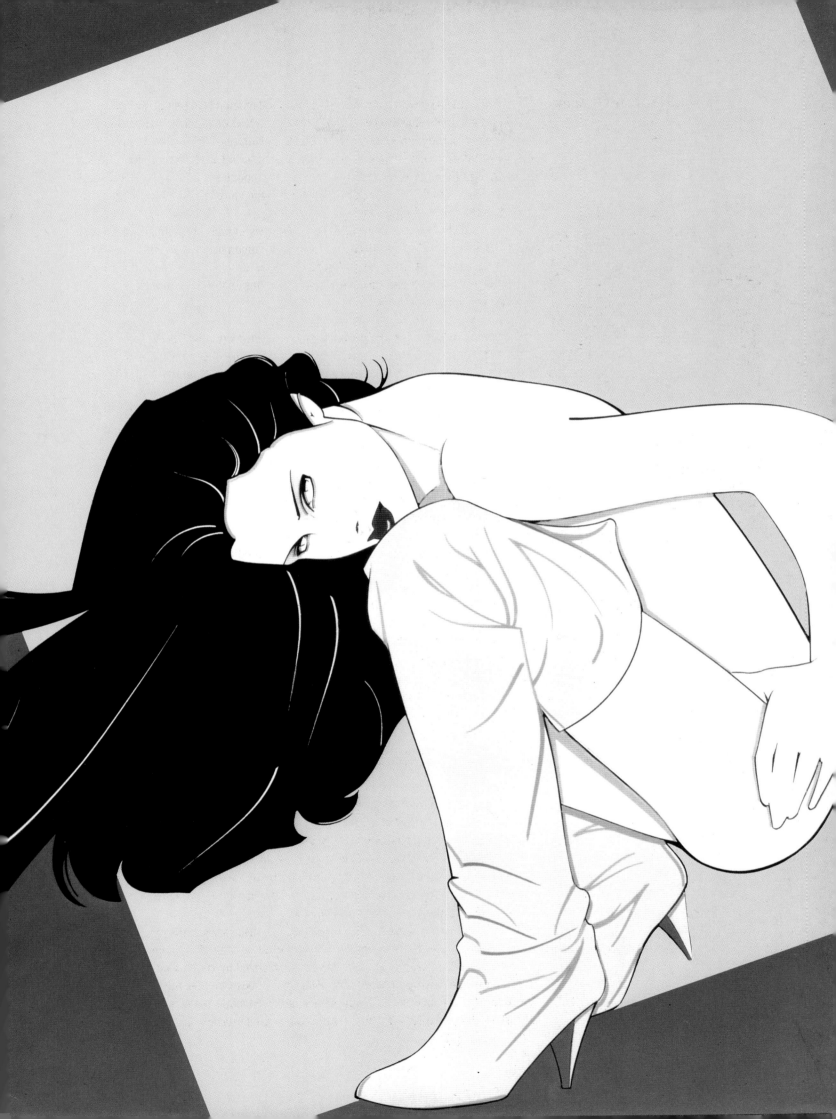

used as many as twenty-two colors per image. Nagel quoted Alfred Hitchcock as having said that the real enjoyment lay in writing the script; the film was the labor. Similarly, Nagel felt that the fun of his work was in the drawing and that the labor was in the painting. He felt that his drawings took him as far as he had to go with a design, yet his finished paintings are amazingly powerful images, rich with color and artfully imaginative. Finally, he would give the finished painting, along with a black line drawing, to the silk-screen printer for execution. These fine silk-screened limited editions and posters won him an international reputation.

Nagel's posters have been in the forefront of the contemporary trend to move advertising art away from the product to other images; they also have an independent existence as a graphic form, tending to obliterate the line between the fine and applied arts. His poster work is a successful amalgamation of art form and advertising medium, following in the tradition of the early masters.

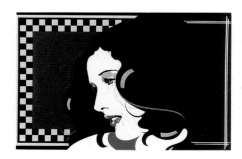

Untitled
Acrylic on board

Nagel also brought his images to life in lush acrylic-on-canvas paintings. His first exhibition of paintings was attended by 4,000 people and was sold out within fifteen minutes. Nagel initially designed his art in small format, a practice related perhaps to his early design work, but his visions were later translated into considerably larger paintings and silk-screens. The large-scale paintings were begun at a time when interest in art was shifting from abstraction back toward realism. This shift brought with it a renewed appreciation of and interest in the human figure. The idealized expression of the human figure is, of course, the focal point of Nagel's work, particularly in his paintings. Perhaps because of their size—some approximately four by six feet, others about three by five feet—the paintings are exceptionally striking, with their rich colors and strong, crisp use of line.

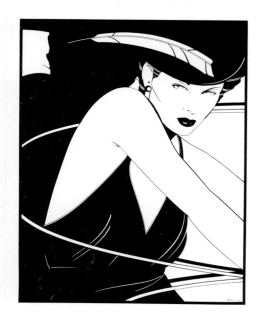

Untitled
Ink on board

In addition to his paintings, Nagel created large-scale graphics silk-screened by hand. These were usually published in limited editions of ninety or fewer and are approximately three by four feet in size. Prior to or within several weeks of publication each of the graphic editions sold out. They include only the basic elements of graphics—line and color—and are as luxurious and stunning as his paintings.

Nagel's dynamic, vibrant paintings prompted famous models and other celebrities to ask if they could pose for him. He designed a limited-edition serigraph for *Dynasty's* Joan Collins, whom Nagel felt had the look of his "woman of the eighties": sophisticated and self-confident, a professional who was not afraid to be glamorous. She now owns five Nagel pieces. Nagel was also sched-uled to do a series of limited-edition silk-screen portraits of Mick Jagger. Like Andy Warhol, Nagel's work often focuses on current cultural concerns, especially as reflected in the stylized form of an ideal woman.

Nagel also completed two bronze sculptures, in multiples of one hundred and eighty each. The sculptures serve as testaments to Nagel's versatility as an artist, as well as indicating new directions in his work. The pieces also recall sculpture of the period of the 1920s and 1930s: *Full Standing Woman* is of a woman who confronts the viewer with a provocative stare while remaining detached and remote; *Bust of Woman* involves the viewer with strong phys-icality—sharp planes imbue the woman with a surreal detachment, while her stylish hat and earrings establish the cultural background.

Nagel's images tend to keep the viewer at arm's length, while also engen-dering a desire to know more. The central figure is almost invariably a woman, and one can trace the rise of the modern-day image of the idealized woman in

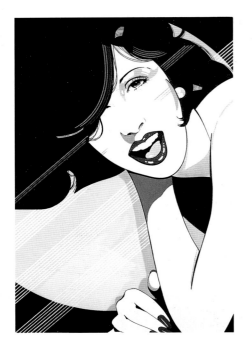

Untitled
Acrylic on board

Nagel's art. His women of the seventies are shown as softer, more pliable, and more innocent than his stronger, harsher, more self-assured women of the eighties. Nagel dealt with current trends, and his look is always timely.

Patrick Nagel was born in Dayton, Ohio, and was raised in the Los Angeles area. He studied fine art at Chouinard Art Institute and at California State University, Fullerton, where he received a bachelor of fine arts degree in 1969 in painting and graphic design. After graduation, he began teaching at the Art Center College of Design, while simultaneously establishing himself as a free-lance designer, illustrator, and painter. His wife, Jennifer Dumas, a successful model, had a great influence on his life and art. She occasionally posed for him, and some have speculated she was the inspiration for the concept we recognize as "the Nagel woman."

Nagel had several one-man shows of paintings and graphics; a retrospective at the prestigious Grunwald Center for the Graphic Arts at UCLA; inclusions in exhibitions at the Smithsonian Institution and the Library of Congress; and numerous painting commissions, from the White House, IBM, MGM, United Artists, Universal Studios, *Harpers,* and *Psychology Today,* among others. Nagel's artistic legacy is vast. His work can be found in the permanent collections of the Library of Congress, the Smithsonian Institution, the Musée des Arts Décoratifs, and the Musée de L'Affiche, in Paris, as well as in the hands of many fortunate private collectors.

Mrs. Millie is curator of the poster collection at the Library of Congress.

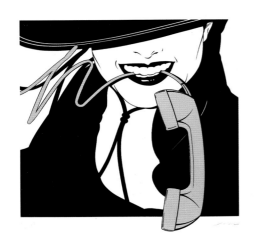

Untitled
Acrylic on board

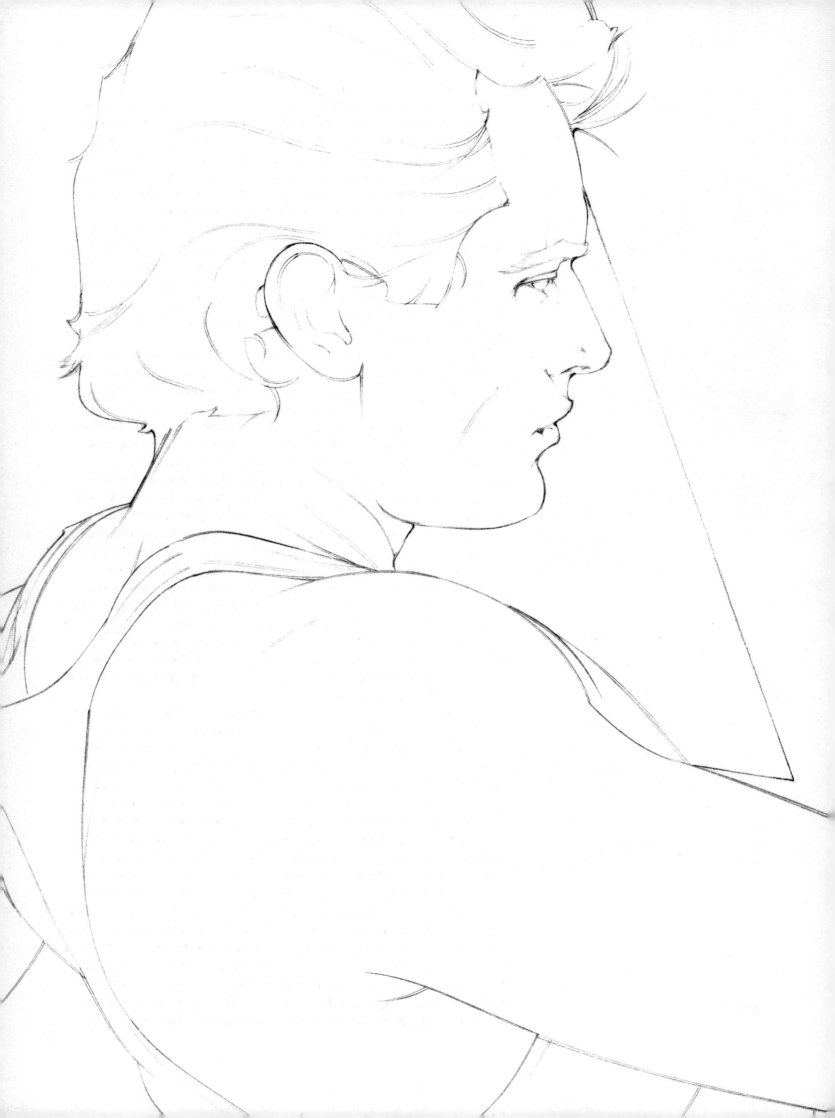

Karl Bornstein:

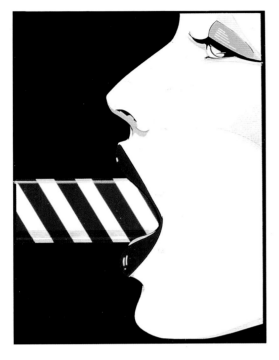

Untitled
Acrylic on board
Playboy illustration

Untitled
Drawing

It almost didn't happen. I was curating a show of album-cover art and I remember seeing a portfolio that had been submitted for the show with striking images of women—white with black lines and color. I asked my assistant who the artist was, and she said, "It's some guy called Patrick Nagel, and I sent him away because I thought you wouldn't be interested in the work!" I immediately called him up, and I remember saying to him, "Listen, Mr. Nagel, I'm looking at your images and I like them a lot and I want to talk to you about publishing your work." I didn't even care about the show I was curating anymore. I simply knew when I saw those pictures that this was the artist I wanted to start my publishing company with. My idea was to create a series of limited-edition graphics unlike any ever done before, to create something that would be art, that would be hand printed by silk-screen, and that would fill a market niche between the very expensive limited-edition prints which were then going for $5,000 each and simple, inexpensive gallery poster art.

He came in. I didn't know what to expect. He was just a tall, quiet guy, a little nervous but relaxed at the same time. We started talking, and he said a couple of wry, funny things, totally deadpan. I didn't know whether he was joking or whether he was very eccentric, so I told him what I wanted to do and how I thought I could increase the potential for success by removing some of the many obstacles. At that first conversation we both sensed that we weren't deceiving each other, just telling the truth. I said, "You know, you're not an illustrator, you're an artist. Just think of yourself as an artist." From the time we started working together I never had an argument with him, though once in awhile we'd disagree about which image to put out. I told him that my intentions were both aesthetic and commercial, but that the key element for both of us was the magic in his art. I've never seen anyone use lines to shape space in its purest form the way he did. He forced perspective out of flat, cool colors. He kept trying to remove as much as possible from the image and still make it have power. For him, the real joy was in the design. The act of painting was a joy to Patrick, but I think it was secondary to using and resolving the human form within a brilliant design. I saw something in Nagel's art that transcends description, but I knew it was what people needed and wanted. His images were ripe for their time. They had that visceral quality that almost invariably stops people dead in their tracks. They were arresting and captivating.

And so began our adventure together, and what grew out of it was beyond business, for it never ceased to amaze us how much we were able to help each other. From the beginning, the response to his images was phenomenal. Working with him was a joy, because no matter what you did for him, he appreciated it, and he never complained about anything. He didn't impose on people, and therefore, everything gravitated to him. He was an elegant, stylish man with the weirdest sense of humor I had ever encountered. He was open to suggestions. If he didn't like something he'd keep on going and come up with something fabulous anyway. I responded to his directness, and I was relieved to find out that he trusted his instincts to the degree that he was almost childlike. The mystery of women was very important to him, and he held women in the highest esteem. But he said once, "I don't think I want to know these women too well. They never come out in the sunlight. They just stay up late and smoke and drink a lot." I was never quite sure what he meant by that, but I think he created his own reality with the images. He loved working them over and over, resolving and revising what he already had going as opposed to artists who constantly move on to different styles and forms of expression. He had fears, but they never immobilized him. Where a lot of people get hung up on what might go wrong, Nagel wouldn't allow

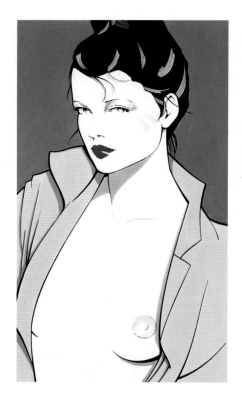

Untitled
Acrylic on board
Playboy illustration

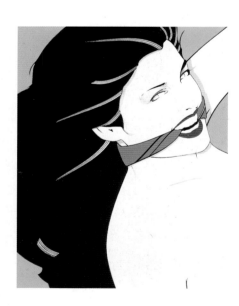

Untitled
Acrylic on board
Playboy illustration

that. He was a doer. He didn't need critical acknowledgment of what he did, because he had such an intense love of just painting pictures. He said that he had always known he wanted to be an artist from the time he was a kid. He never questioned it, and he never looked back. He just knew what he wanted to do and he did it. He liked to let the images speak for themselves—he never pitched the images; in fact, he never pitched anything.

The success of Nagel's work truly startled him. He was having so much fun doing them that I think he was somewhat afraid that if he became too successful he would have to take it all too seriously, but that never happened. He used to say that one day he would wake up and all this would be over. I think his enormous success can be explained by his appeal to those who are fascinated by the mysterious, cool end of the figurative spectrum. He danced along the edge of illusion; he played with the power of paradigms—of beauty, grace, style, aloofness, and mystery; he brought those qualities back to a world that is at times too serious and bleak.

Patrick was anything but what people might imagine him to be, given what he did for a living, which was to recreate beautiful women in a two-dimensional reality. I wouldn't call him saintly, but he was a rare and self-realized person. He loved to drop a one-liner or a bizarre comment at the most unlikely times. He was so peaceful, I used to call him Perry Como, because nothing ever rattled him. I used to say that if someone were to come up and mug him, Patrick would probably offer him a ride home.

When I think about the way he died I realize it was typically Nagel. He never used to work out, but would eat cheeseburgers and candy bars and laugh at people who would think about being healthy. He used to smoke, stay up all night, and paint. The night before he died we were having dinner with a client and talking about doing Mick Jagger's album cover with a portrait of Jagger, somewhat like what Nagel had done with Duran Duran. The Duran Duran cover is an interesting story because for months, I think people recognized the cover without knowing who had done the album. It took about eight months for the album to take off, and when it did, it became the number-one album in the world. Anyway, at that dinner I asked him what he was doing the next day, and he said that he was going on a benefit show to raise money for the Heart Association—jump around and be on TV and do some aerobics—and I said, "Patrick, you're going to do aerobics? You never work out!" He replied, "Don't worry about it." So the next day, there he was, jumping around on television. Afterward, he walked out to his car and had a heart attack and died.

He simply was not a worrier, and he loved a good time. I recall one evening when he said, "I'm going to have a party. What I'm going to do is have a scavenger hunt, and I'm going to rent twenty limousines and it's going to be a black tie scavenger hunt." And that's what it turned out to be—crazy elegance and one of the most interesting evenings that I've ever had. It wasn't until three years into our relationship that he told me that he had been a ranger in combat in Vietnam. I think he had come to some kind of inner peace with himself through that experience; I also think his sense of humor reflected that. Occasionally you could feel the edge of his pain about it, though he didn't come back an immobilized person like many did. I think he came back grateful to be alive and able to work at doing what he loved most, making pictures.

Nagel and I were like these two young kids who had a dream, an idea, and then grew up with it. We gave each other all we were capable of and it worked. One day he looked at me and said, "You know, you're my best friend," and it almost knocked me over because he had never talked about it before. The adven-

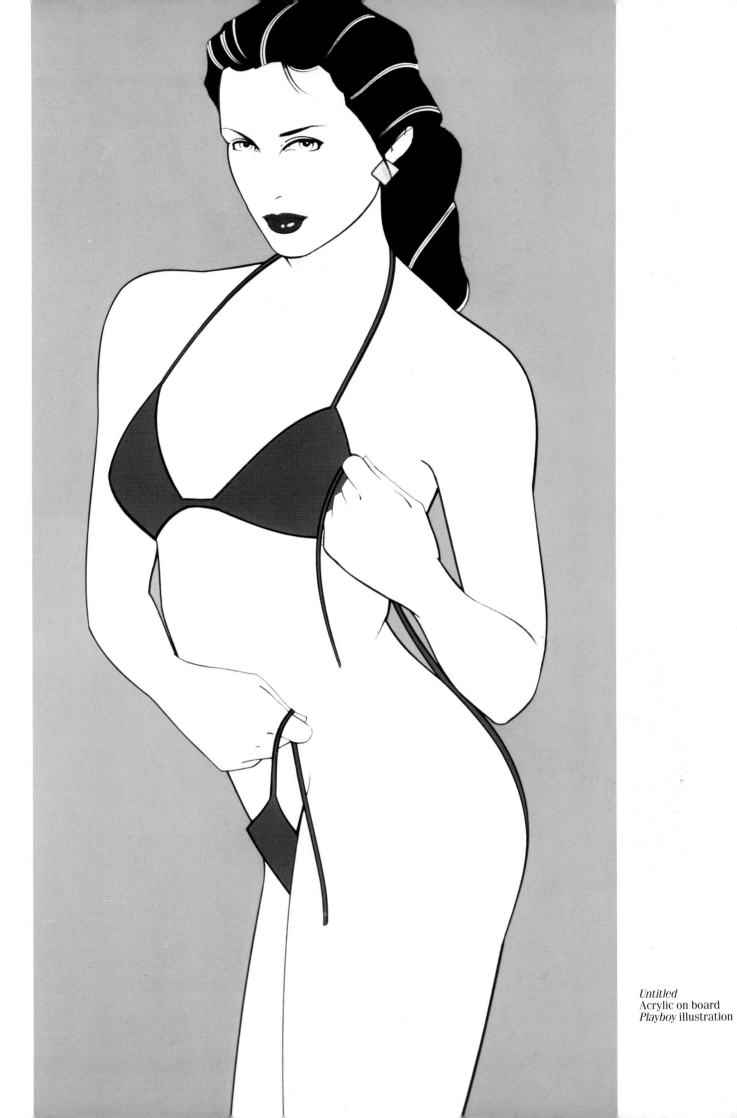

Untitled
Acrylic on board
Playboy illustration

ture that I experienced with Patrick is something that most people dream of all their lives, a magical combination of love, friendship, success, and joy. It enriched my life in much the same way that art enriches me, by giving me a feeling of having completed a great and wonderful experience. So this book represents a catharsis for me, a tribute to an all-too-brief career, and the completion of a relationship.

Nagel was my friend and my companion, and we had a lot of fun being successful together. If I know Nagel, he's probably having a martini with David Niven at a piano bar right now. Our friendship was the grandest fantasy imaginable, and I shall always be grateful that it happened.

Barry Haun:

Patrick Nagel used more Payne's grey than any other painter ever.

He never wore short sleeves.

He loved women.

He especially loved women with strong noses.

He thought *Pennies from Heaven* was a great movie.

He could play the accordion. He said his mom bought anything from anybody, and there was this door-to-door accordion salesman....

He loved peanut M&Ms, chocolate shakes (not too thick), fried onions, and coffee.

He said that if I wanted to work for him I would have to learn how to juggle. Why, I don't know, but now I can juggle.

He wanted to paint Jessica Lange's portrait. Cher's, too.

He would stop work if he was out of Pepsi or coffee.

He thought exercise was stupid. For him, it turned out to be.

I had seen Patrick's work long before I had an idea of who he was. I didn't know if the work was done by a man or a woman, but it appealed to me like nothing before had. I remember commenting, "If I could apprentice under anybody, it would be this person." Watch out, you may get what you're after! In less than one year I was Pat's assistant. At first I was intimidated, but Pat had a way of making everything seem simple. He was the most even-tempered, good-natured person you could ever meet. Joe, his dog, is the same way. I'm willing to bet there isn't a person who met Patrick who didn't immediately like him. It was hard for me to imagine him as a paratrooper in Vietnam with eighteen jumps into the middle of combat. I can just picture his saying, "You guys go ahead. I'm going to sit here and finish this cigarette." The only thing I ever asked him about that experience was what it was like to get shot at, and he said, "You learn to not take it personally."

I think I became quite spoiled working for him. I could get up at six, be at the beach by seven, surf until nine, and still be at work by eleven. At times we'd start with a photo session using the most beautiful girls imaginable. He would have already worked up thumbnail sketches of what he wanted to do, but he tried not to preconceive too much. Often, he would go out and buy the models outfits, usually bringing in makeup and hair stylists, too. The sessions were always very professional. You could tell that he loved women, being drawn more to their sensual qualities rather than to their overt sexuality. He also loved details; for instance, he would talk about how women would remove a small bit of tobacco from their mouths with great delicacy in the days before cigarettes were filtered. He used many different models, but there were a couple of favorites.

From the photographs he would work up drawings and then transfer them

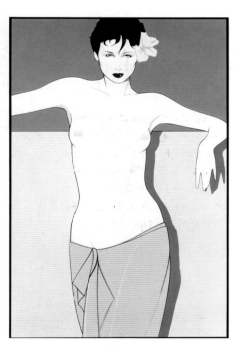

Untitled
Acrylic on board
Playboy illustration

to illustration board or canvas, inking in lines, choosing colors, continually making subtle changes, working on the shading, finishing out the detail. There were quite a few steps before we had a completed image that could be shipped off for silk-screening or exhibition. Pat sometimes had a hard time relaxing, but daily he would take a nap on the floor. He would occasionally get nervous about getting started on a new piece or about a show deadline.

Work normally would start at eleven and continue until six, at which time we'd knock off, I'd go home, and he'd go upstairs to where he lived. There were times when I'd drop by at three in the morning and he'd still be in the studio with the TV on, drinking coffee or Pepsi, and painting. At first I thought the work would get old for me, but that didn't happen. I was continually amazed by the new images he'd come up with, and he was constantly refining and improving them. He was very visually oriented, and his sense of design, color, and line was uncanny. Besides drawing and painting, he was becoming excited about the sculpture pieces and wanted to develop more.

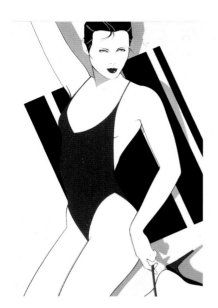

Untitled
Acrylic on board
Playboy illustration

It will always be the idealized women he will be remembered for, but he also wanted to do more male images, as people responded well to the ones he did. Pat also loved photography and would have liked to become a better photographer, but he felt that photography was too technical for him, so he would paint what he wanted to capture on film instead. He liked the work of high-fashion photographers, as well as other illustrators such as Joseph Leyendecker, Henry Raleigh, Saul Tepper. He especially loved the pre-Raphaelite painters.

Although Nagel possessed wit and style, he loved to watch TV. He'd come into the studio and plan out his day with the TV schedule. *Superman* was definitely a favorite, though he thought Lois Lane was a bitch. He'd also be disappointed if he had an appointment during a Laurel and Hardy film. He liked sound tracks from spaghetti westerns, like *Once Upon a Time in the West,* and he liked early rock and roll of the fifties, Presley, Sinatra, Cole Porter, Les Paul, and Paul Desmond.

He was amused by his success, but he didn't get a big head about it, he was just very happy being able to make a living from his work. He was thrilled by simple things—a fan letter from Tasmania, prisoners writing to tell him how they hoped to be artists when they got out, people saying they had bought furniture to match his art, some people buying as many as ten or twenty of his images. He was a check grabber at restaurants, he loved to drink martinis, he was hungry for trivia. He loved jokes; I can't tell you how many bad jokes we traded and had to endure. But what are friends for?

Joan Collins:

I feel flattered, like most would, whenever I'm asked to be the subject of a work of art. I've had the privilege of being photographed by some of the best photographers, from Hurrel to Helmut Newton; styled by some of the best designers, from Erté to Valentino; and painted by some of the best painters, from Warhol to Nagel.

Nagel's bold portrait of me is prominently displayed in my living room, which is the appropriate room for this my favorite painting, since Nagel painted me looking comfortable, accessible, and luxuriously relaxed, as if I had been taking a private respite in a familiar ambiance.

In fact, it was in my living room that Patrick Nagel first met me and photographed me, creating the image for the successful serigraph succinctly named *Collins.* It is flattering again to think that others have invited Nagel's

sensuous yet austere image of me into their own living rooms and boudoirs.

Nagel's body of art is paradoxically strong yet vulnerable. He was a sleight-of-hand artist, painting less while revealing more. There is a seductive magic in his paintings.

I remember when he first photographed me he remarked that my lips were my most outstanding facial feature. He said they seemed to have an anatomy of their own. Never have lips felt so naked. He had a way of seeing every detail and revealing them all on canvas.

Needless to say, I was truly saddened by my friend Patrick Nagel's untimely death. As an artist he was completely original, a total innovator whose drawings and paintings broke with many traditions. He captured the very essence of his subjects in a glamorously glorified yet simple way.

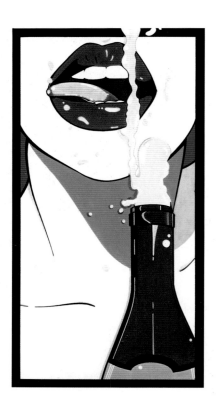

Untitled
Acrylic on board
Playboy illustration

opposite page:
Lori
Acrylic on canvas

Hugh Hefner: When Pat Nagel began illustrating "The Playboy Advisor" in 1976 he was a young artist looking for a break. Because of its openness to new visions, *Playboy* has long had a reputation as a showcase for talented young artists, from LeRoy Neiman through such later lights as Brad Holland and Mel Odom. We did not know it then, but in the next eight years Pat would do as much as anyone to strengthen that reputation.

At first we asked him to illustrate a particular letter to the "Advisor" every month, but soon it was clear that trying to funnel such a large talent so narrowly was like telling Irwin Shaw or Ray Bradbury what to write about. We changed the rules. We asked him simply to give us a painting a month. As it turned out, the painting he gave us invariably illuminated one, two, three, or *all* of that month's "Advisor" letters in a way no commissioned illustration ever had. He captured a feel, a smooth electricity in women, that others have seen but no one else has put on canvas.

Before long we were receiving letters about the unsigned "Nagel girls" in the "Advisor." *Who is this guy? Where can I see more of his work? He's different, he's striking, he's new.* Pat's work soon accompanied *Playboy* fiction, nonfiction, and travel and fashion features, all with the effortless grace he brought to the "Advisor."

He was a pop artist who became a creator of fine art, and at the time of his death he was just reaching his peak. "Nagels" had moved from the "Advisor" to the rest of the magazine, from there to the walls of hundreds of galleries, and from there to prime placement in the windows of those galleries. Pat had arrived.

He was a sudden success—a genius to some—but as his professional style developed, his personal style remained modest. "He was taller and nicer than you imagined him," said an acquaintance—not a bad way for any of us to be remembered. He was generous almost to a fault, often donating paintings to his models or to editors who expressed admiration for his work. He always seemed surprised that he could inspire such excitement.

This book contains that excitement. I would like to do descriptive justice to his work here, but words could never capture Nagel. That is the reason we published in the January 1985 issue of *Playboy* a tribute to Nagel the artist and Nagel the man. We miss them both a great deal.

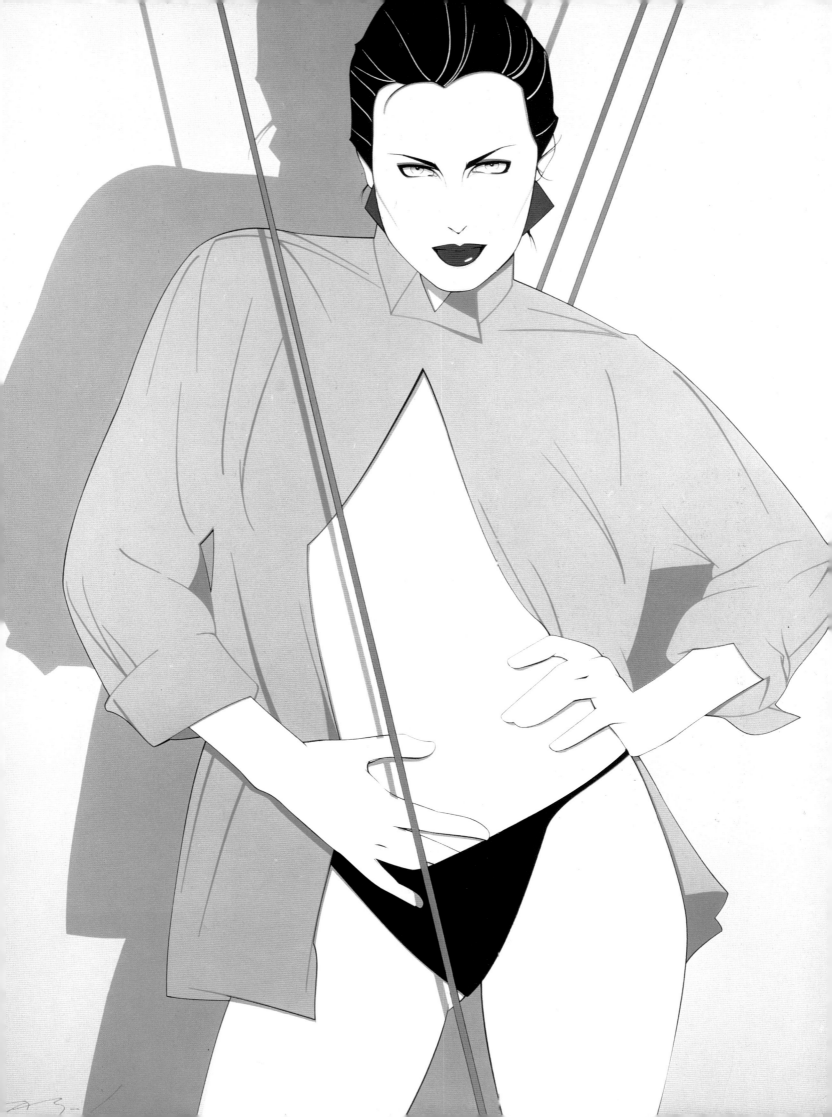

Untitled
Acrylic on canvas

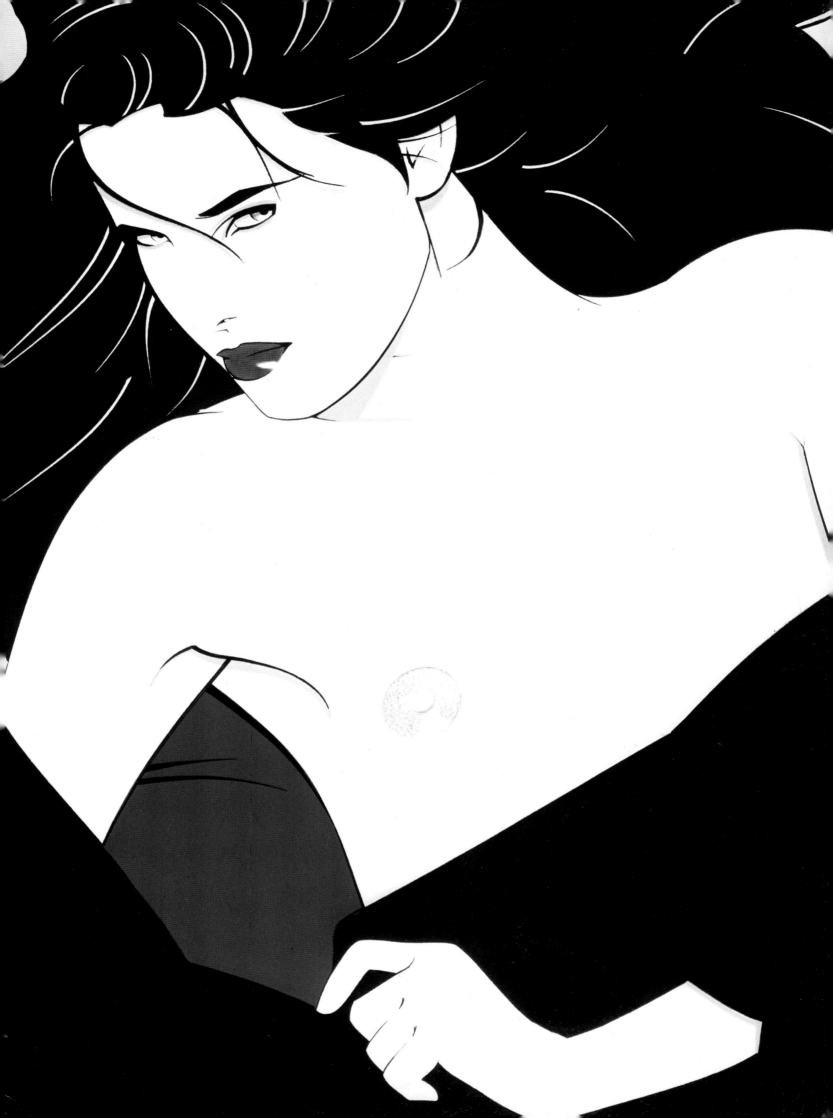

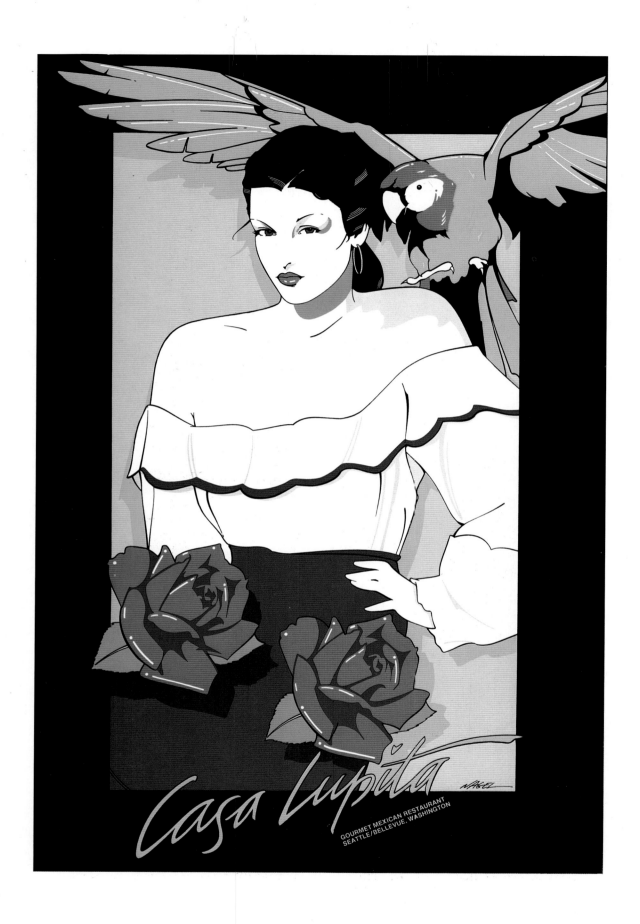

Casa Lupita
Serigraph
Limited-edition poster

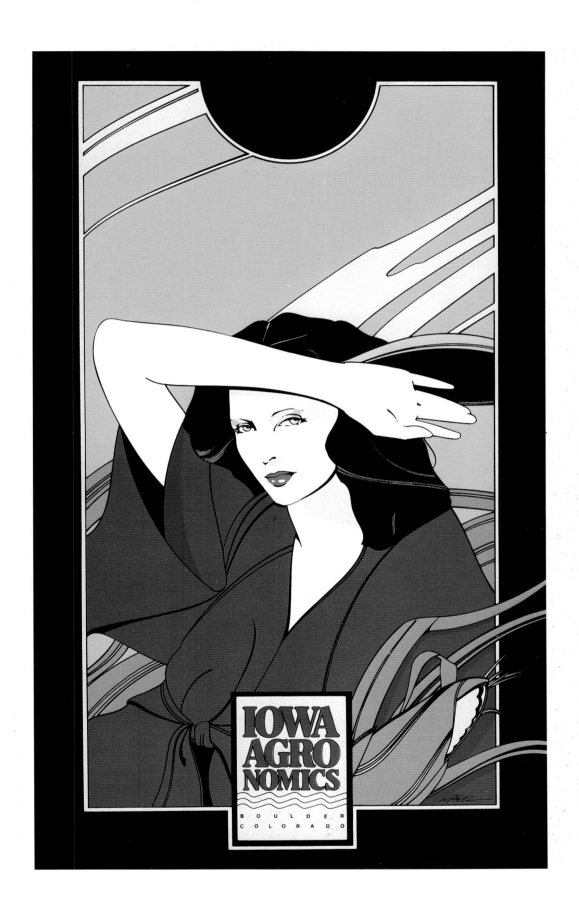

Iowa Agronomics
Serigraph
Limited-edition poster

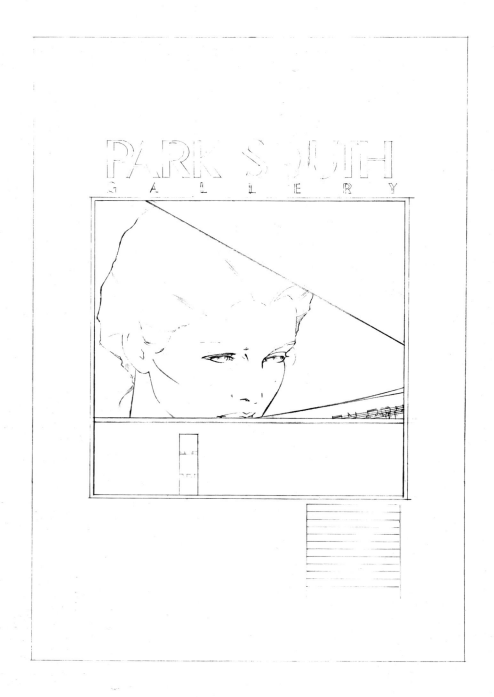

Park South Gallery
Drawing

Park South Gallery
Serigraph
Limited-edition poster

PARK SOUTH GALLERY
AT CARNEGIE HALL

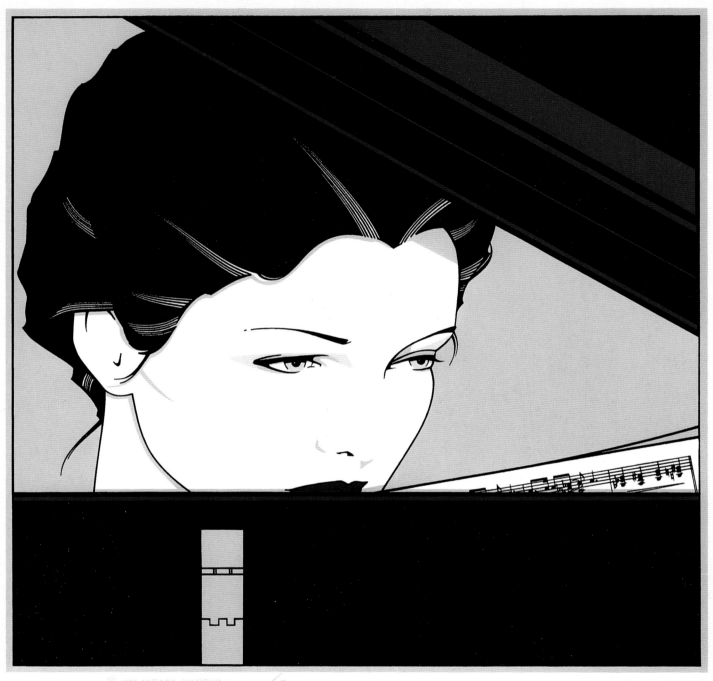

©1979 MIRAGE EDITIONS A/P

ART	NOUVEAU
ART	DECO
ORIGINAL	POSTERS
885 SEVENTH AVENUE	
NEW YORK CITY	
NEW YORK 10019	
212	757-5469

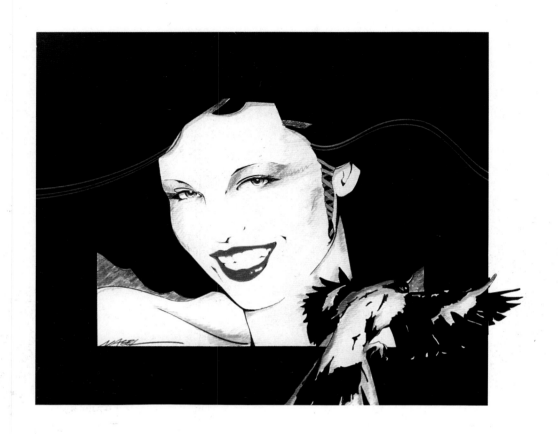

Untitled
Acrylic and colored pencil
on board

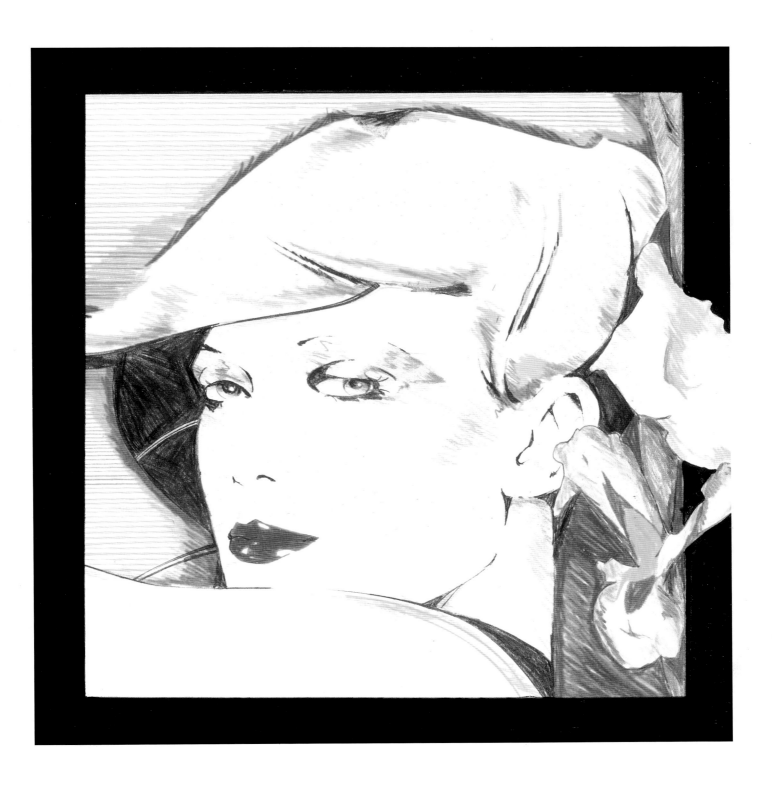

Untitled
Colored pencil on board

Mirage Gallery
Serigraph
Limited-edition poster

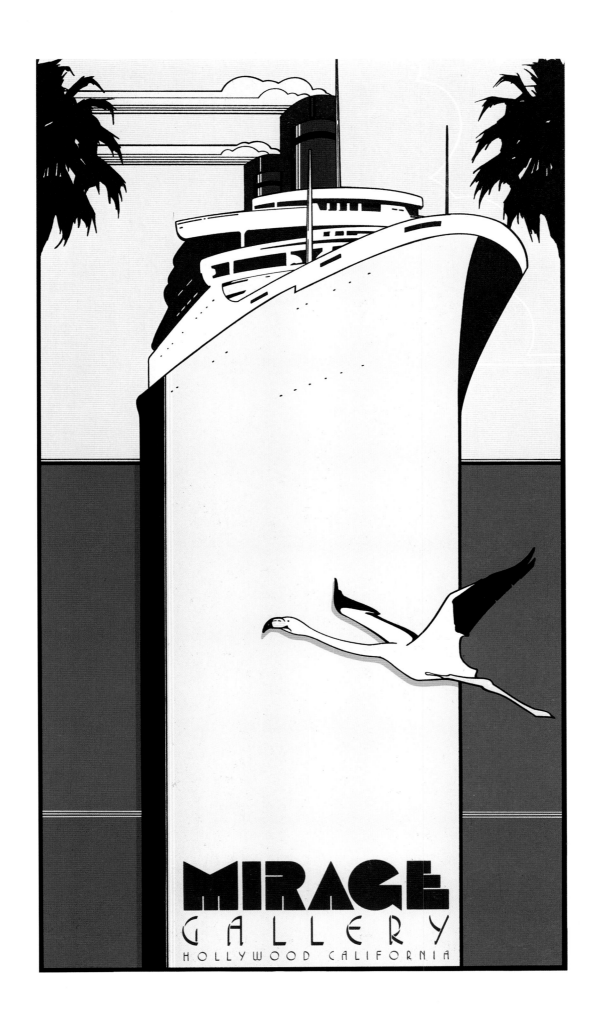

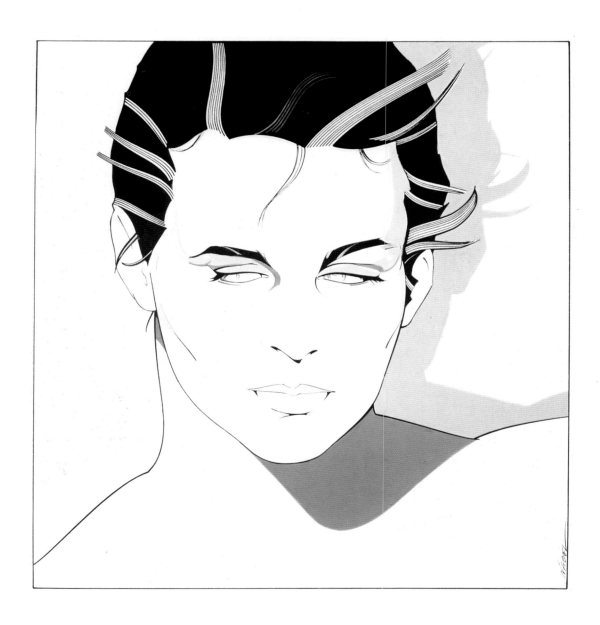

Untitled
Acrylic on board

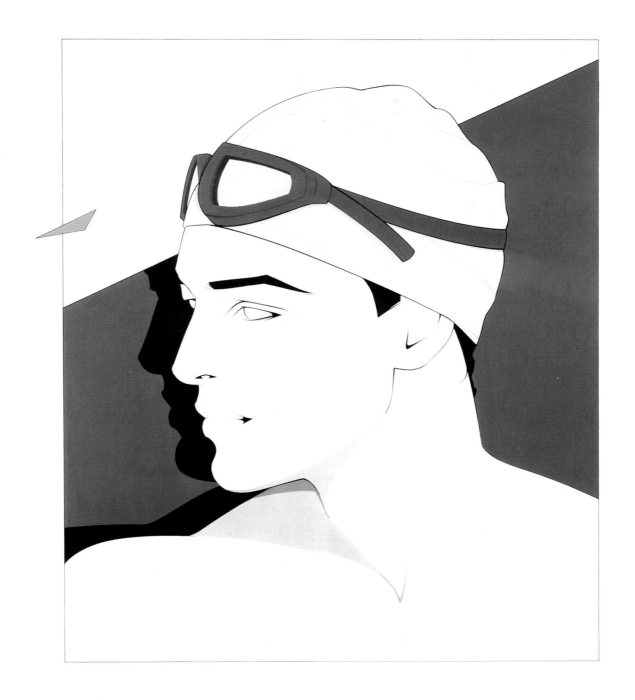

Untitled
Acrylic on board

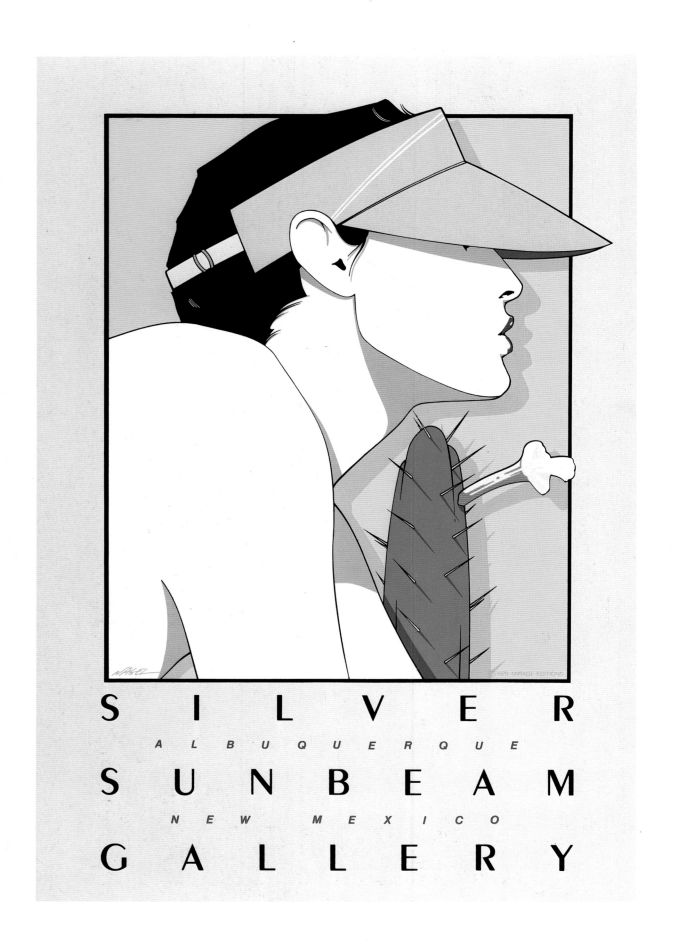

Silver Sunbeam Gallery
Serigraph
Limited-edition poster

Art Expo, Cal
Solid-plate lithograph
Limited-edition poster

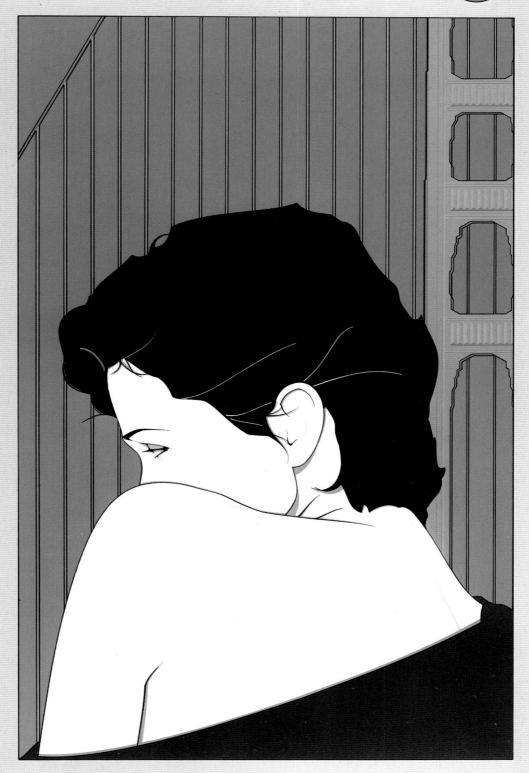

ART EXPO CAL

SHOWPLACE SQUARE
SAN FRANCISCO CALIFORNIA
OCTOBER 22-26 1981

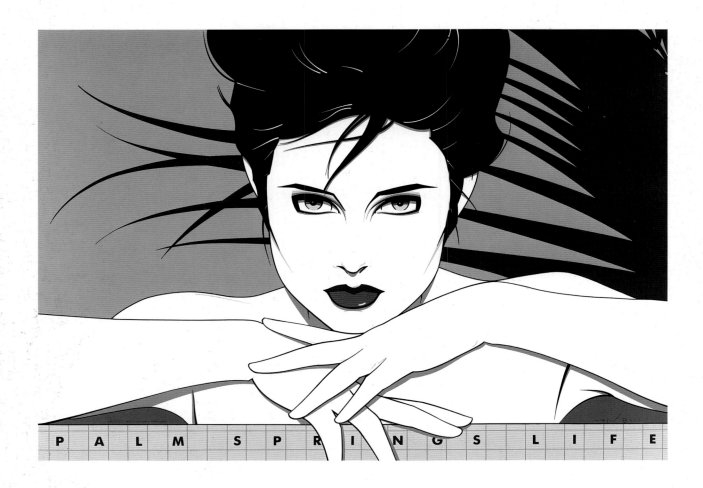

Palm Springs Life
Serigraph
Limited-edition poster

Untitled
Acrylic on canvas

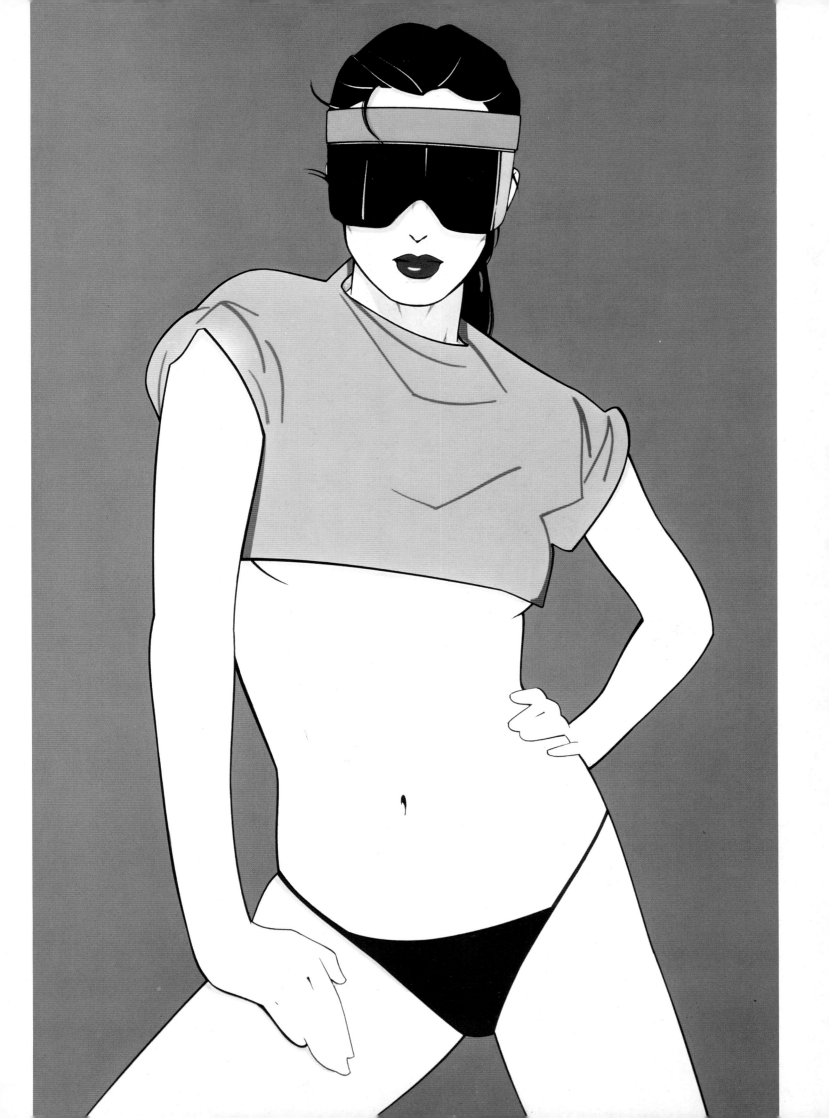

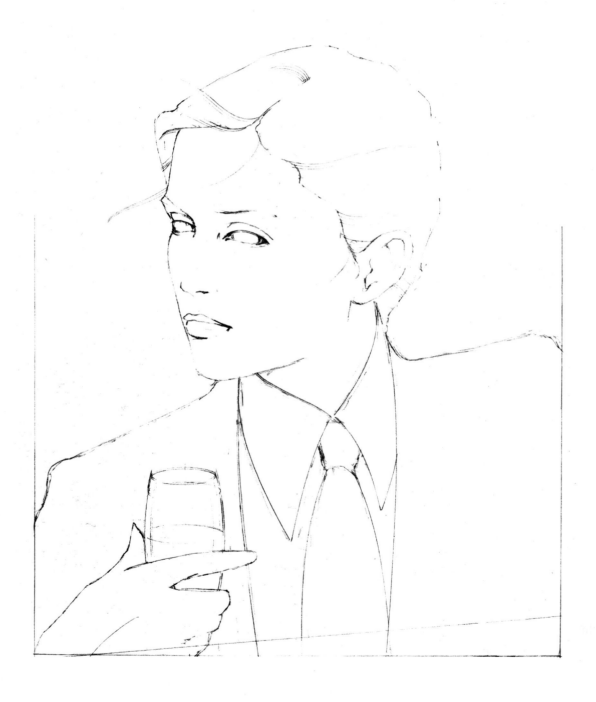

Mother Earth's, Paris
Drawing

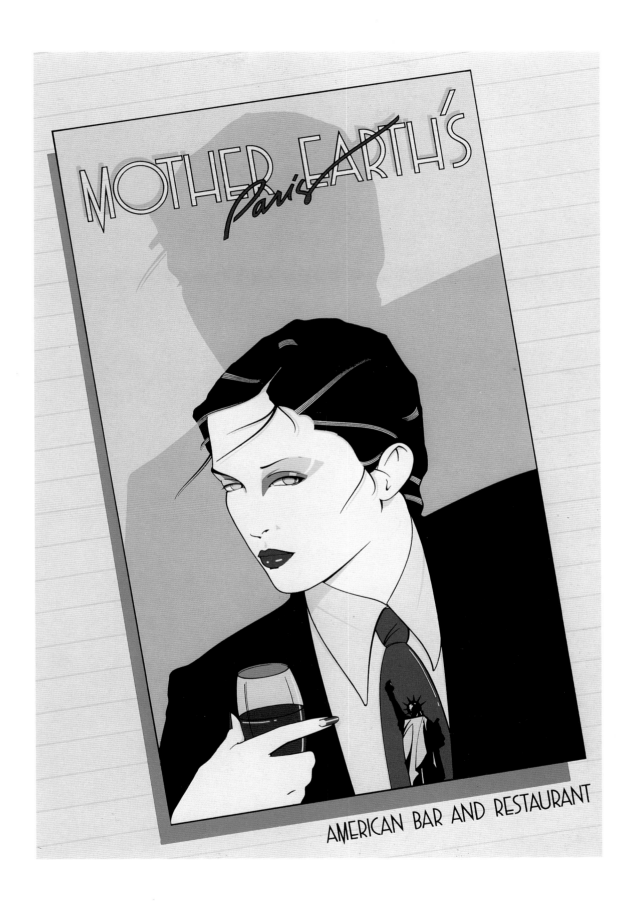

Mother Earth's, Paris
Serigraph
Limited-edition poster

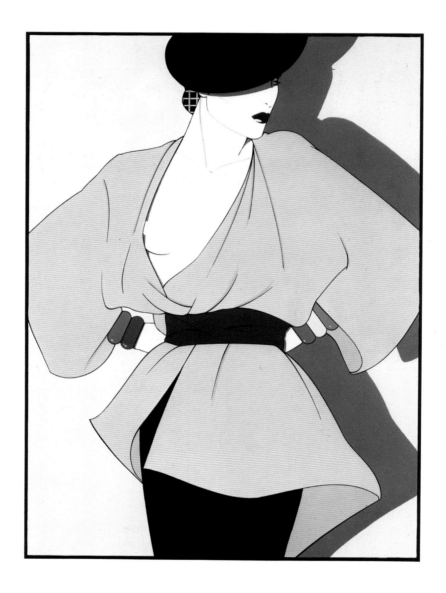

Untitled
Acrylic on board
Playboy illustration

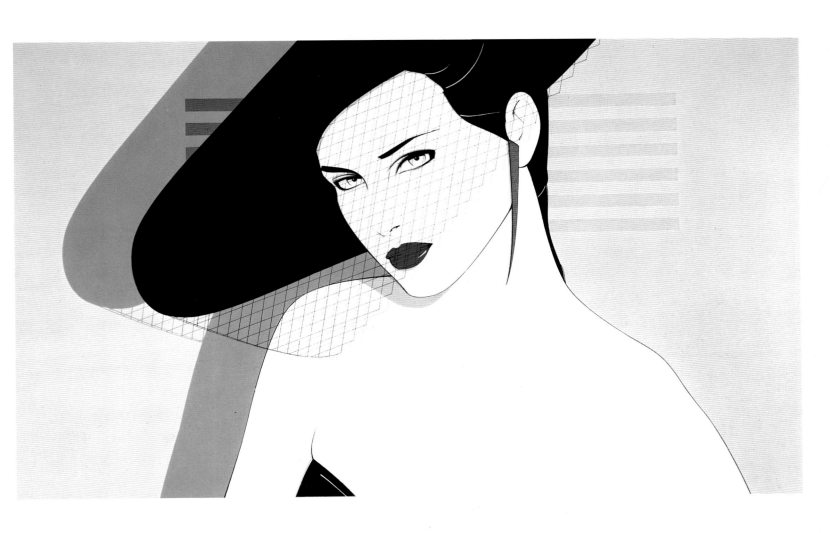

Untitled
Acrylic on canvas

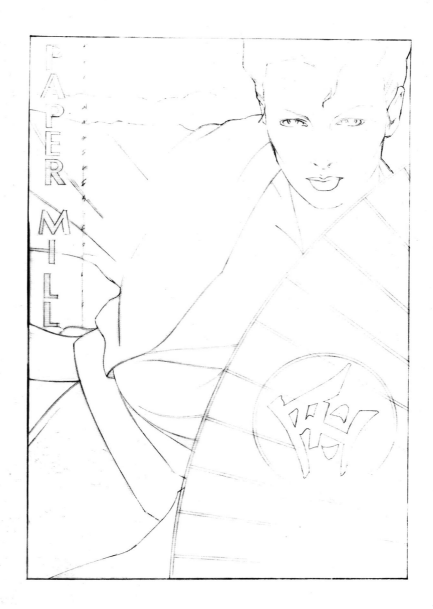

Paper Mill
Drawing

Paper Mill
Serigraph
Limited-edition poster

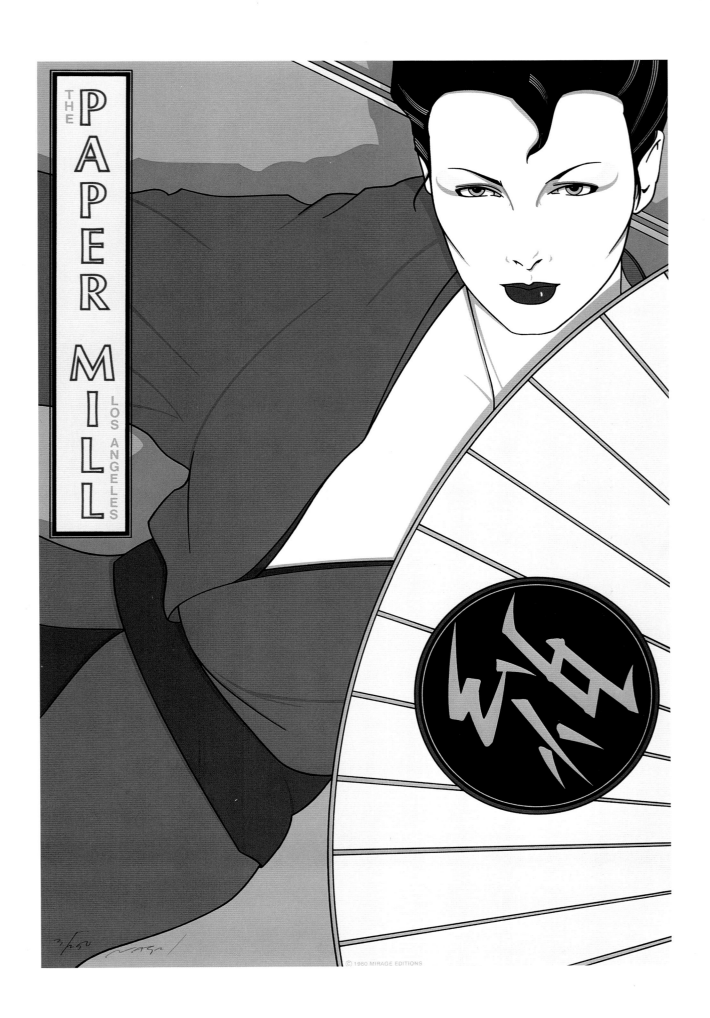

THE PAPER MILL LOS ANGELES

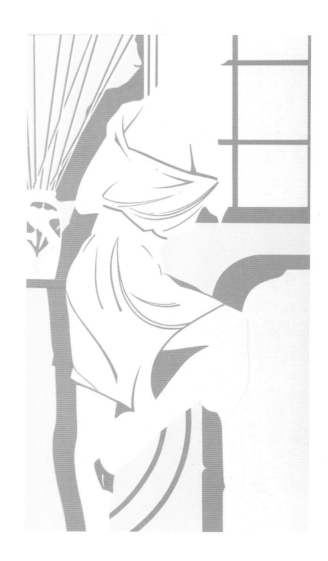

Just Looking
Serigraph progressive set

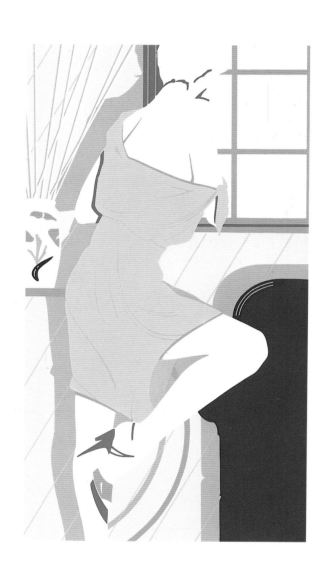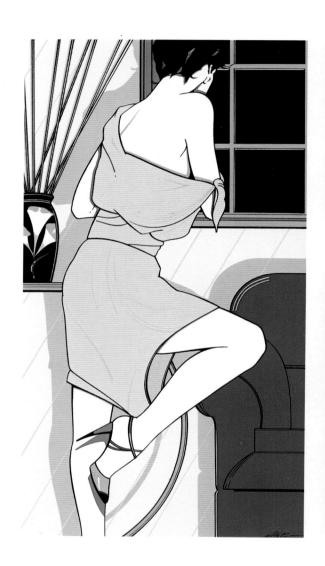

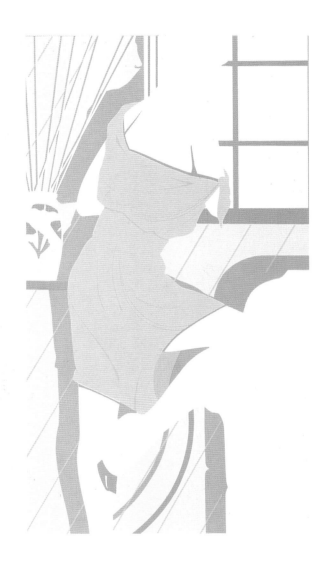 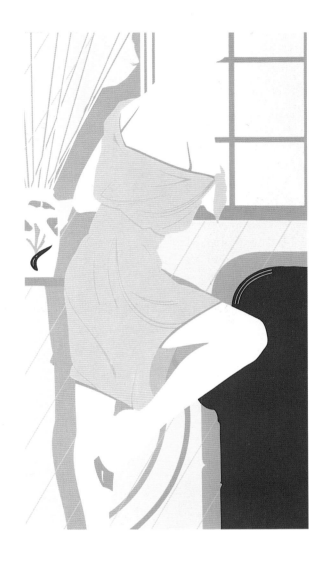

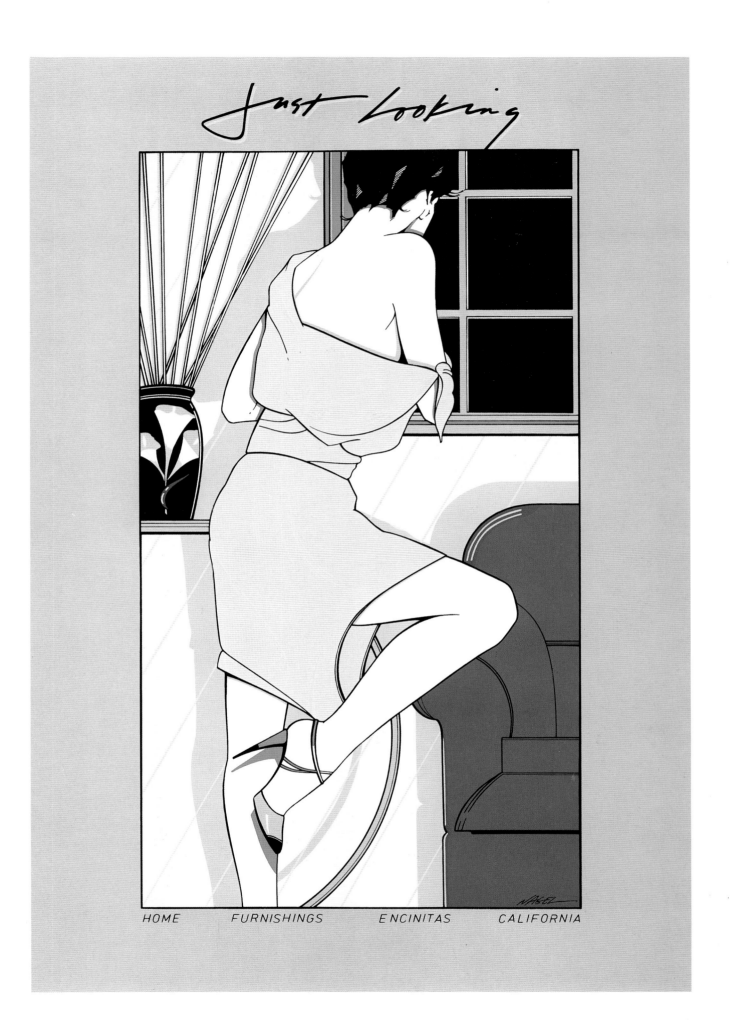

Untitled
Acrylic on canvas

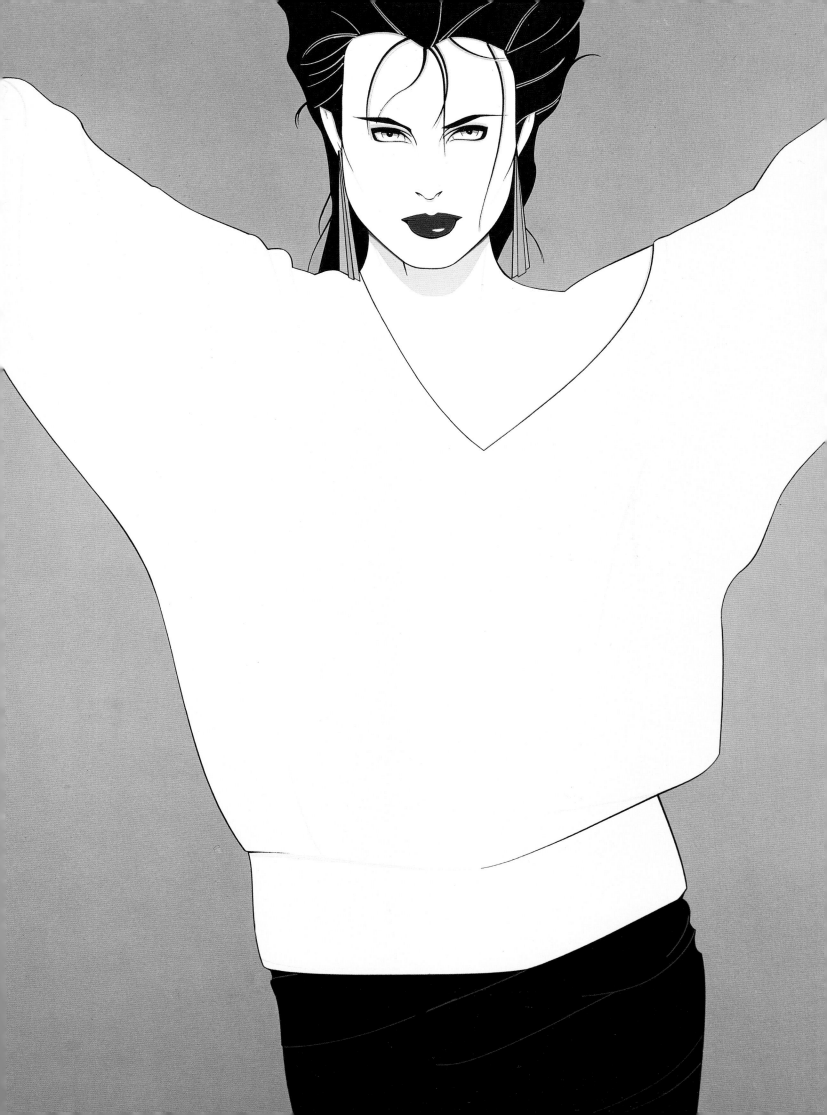

Untitled
Acrylic on canvas

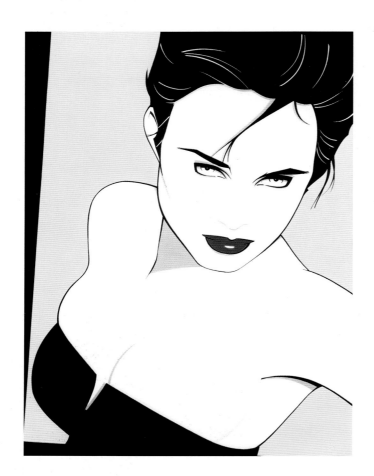

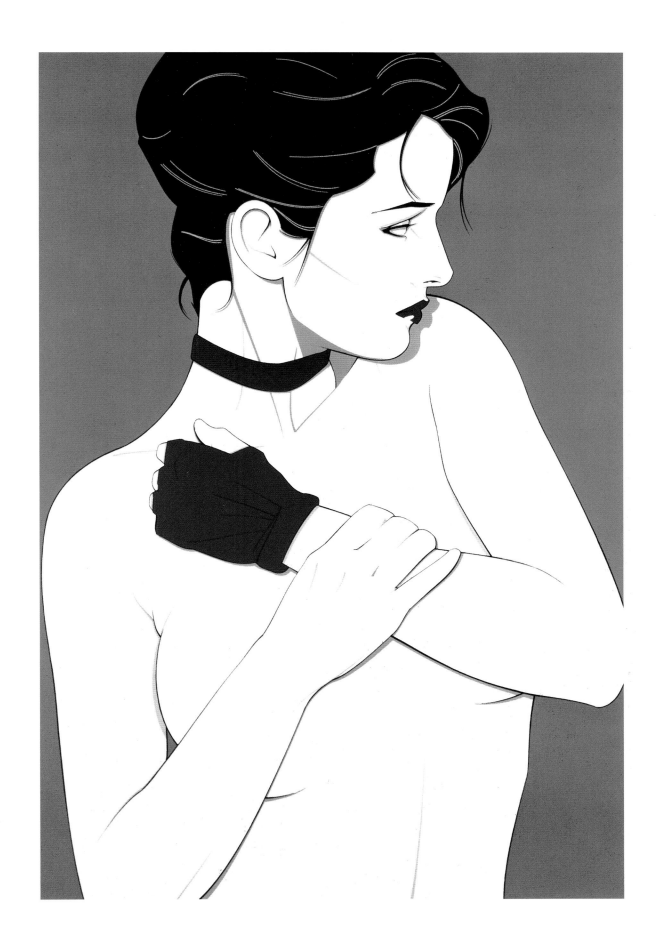

Untitled
Acrylic on canvas

Untitled
Acrylic on canvas

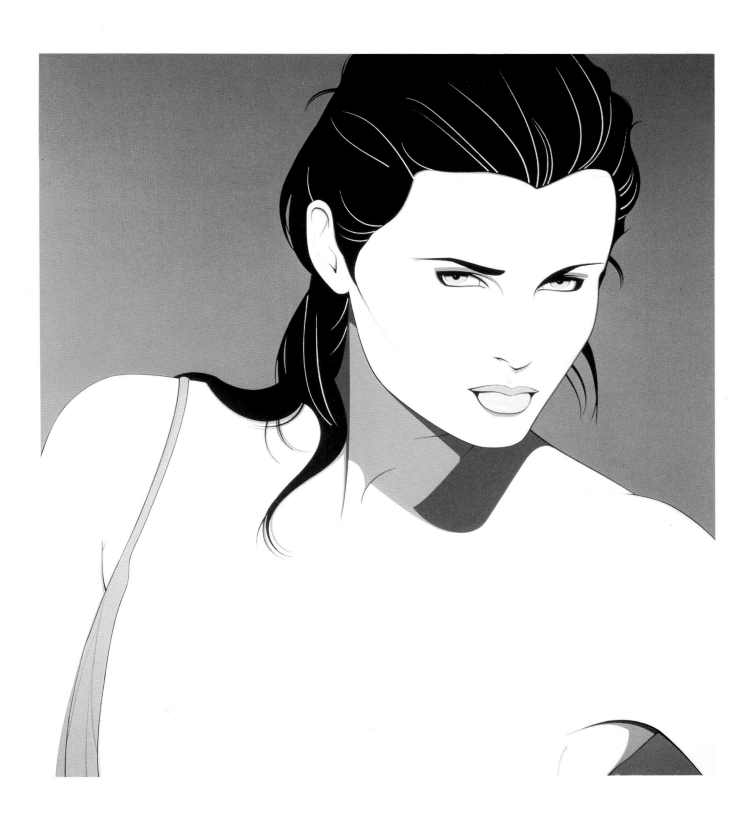

49

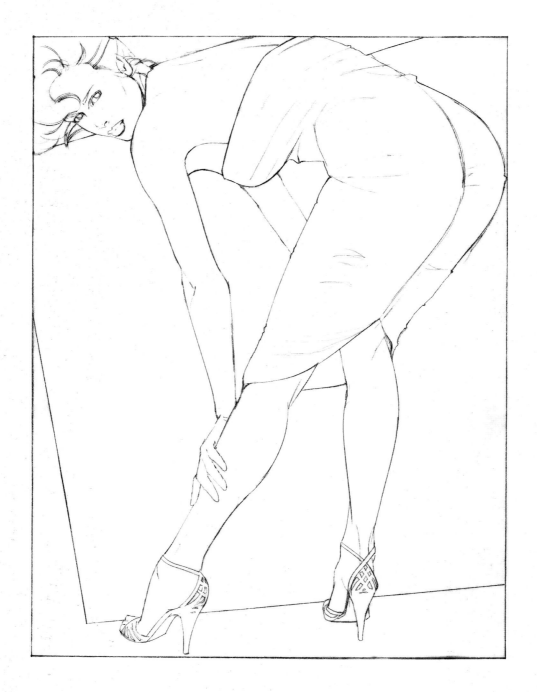

Shannon
Drawing

Shannon
Acrylic on canvas

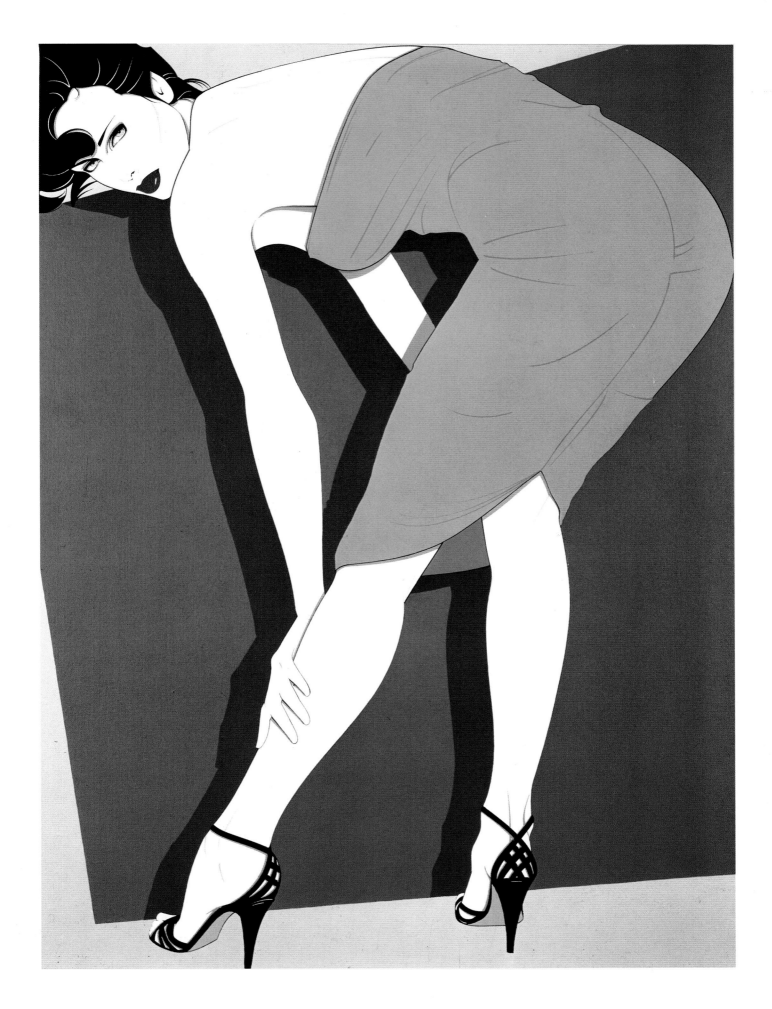

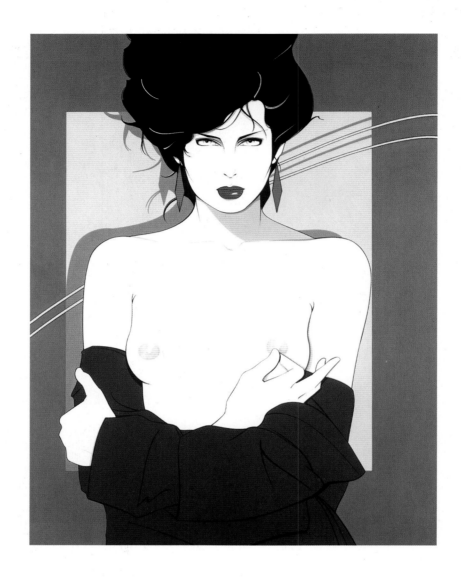

Untitled
Acrylic on board
Playboy illustration

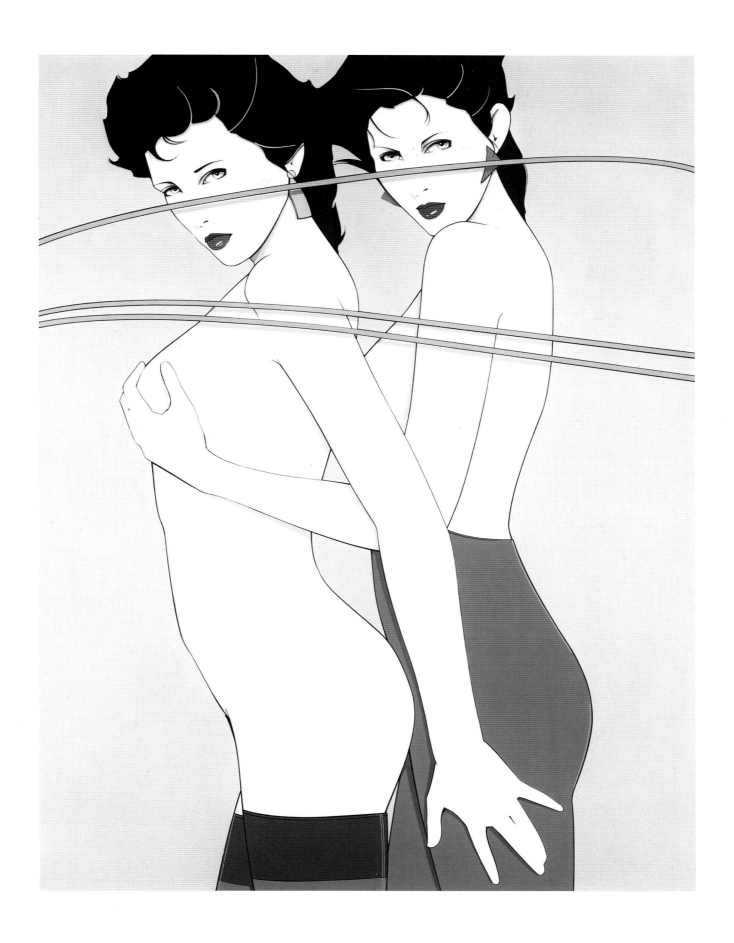

Untitled
Acrylic on board
Playboy illustration

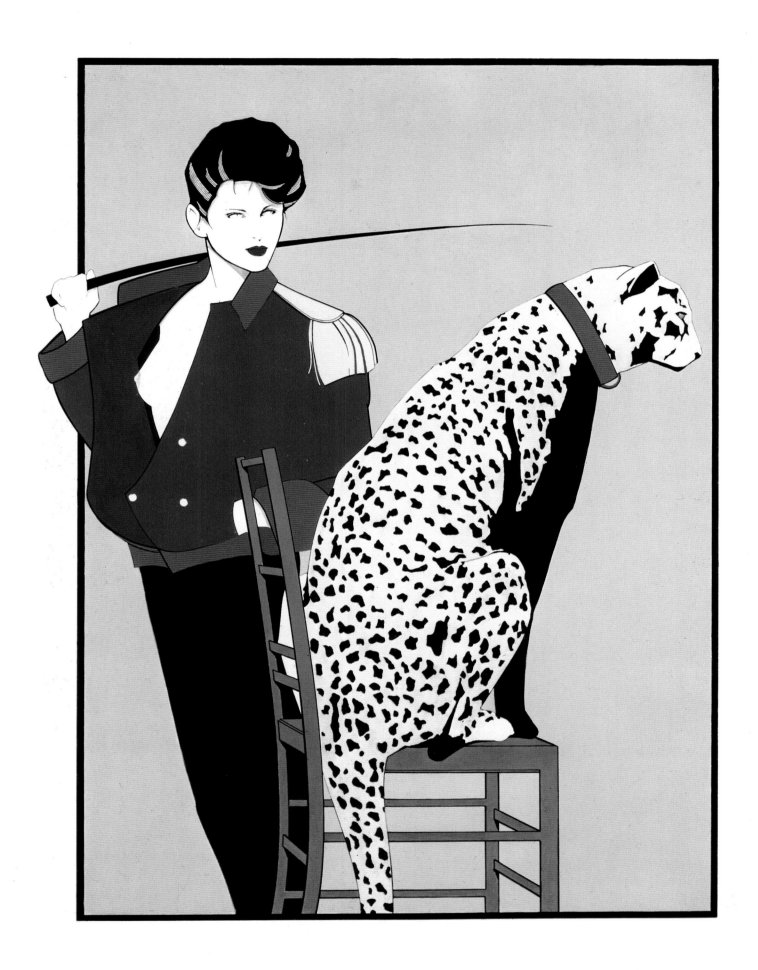

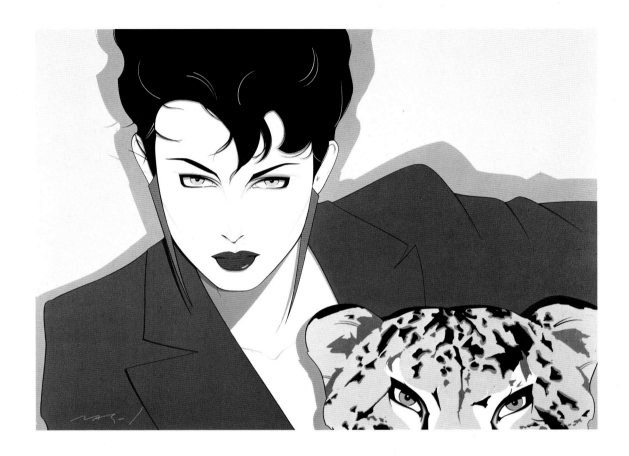

Cheetah
Acrylic on canvas

Untitled
Acrylic on board
Playboy illustration

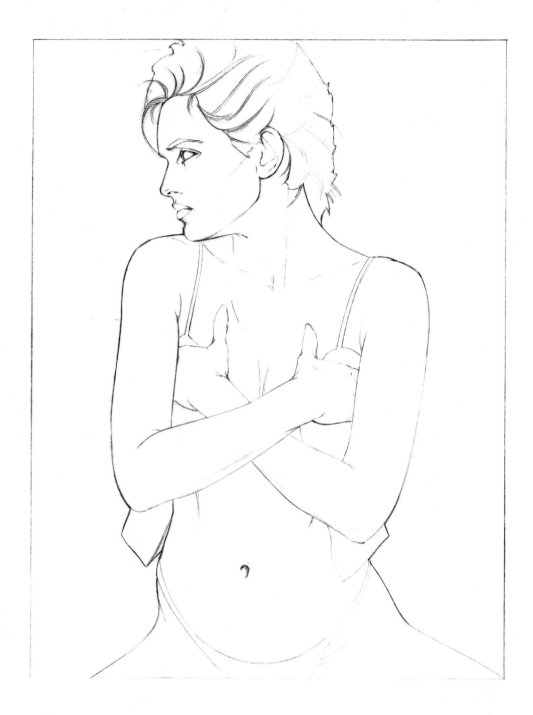

Untitled
Drawing

Untitled
Acrylic on canvas

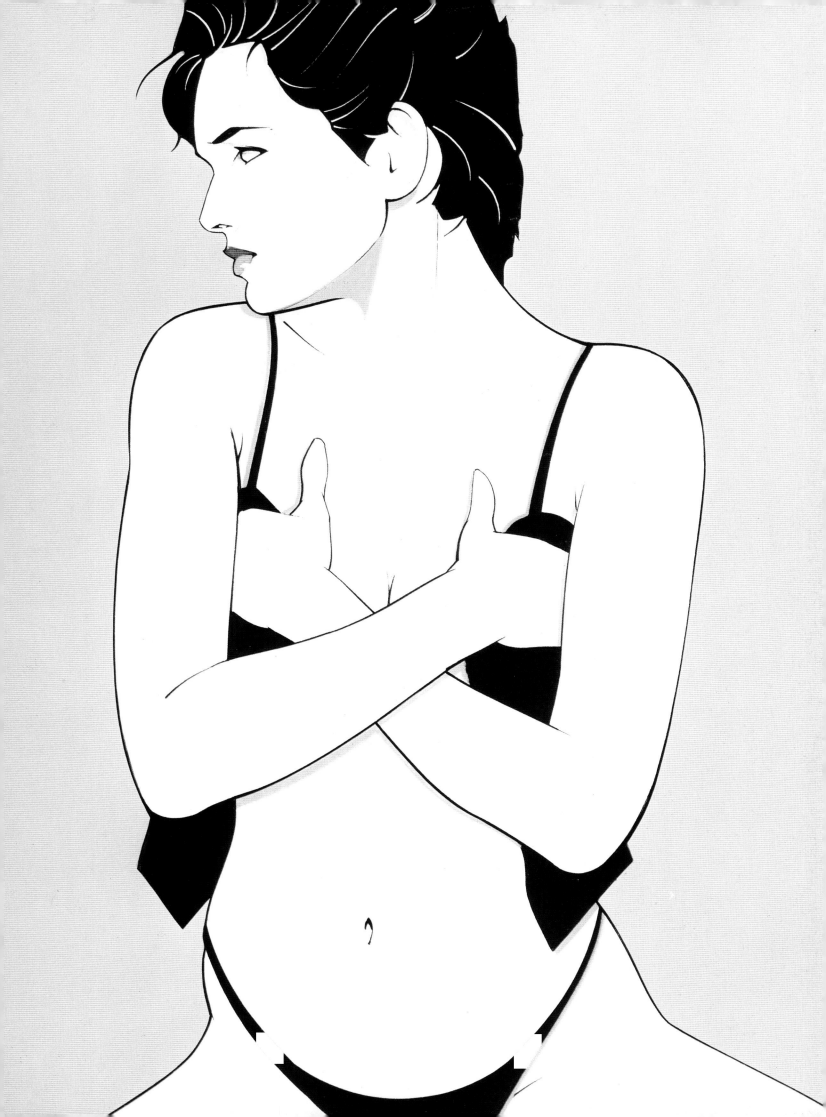

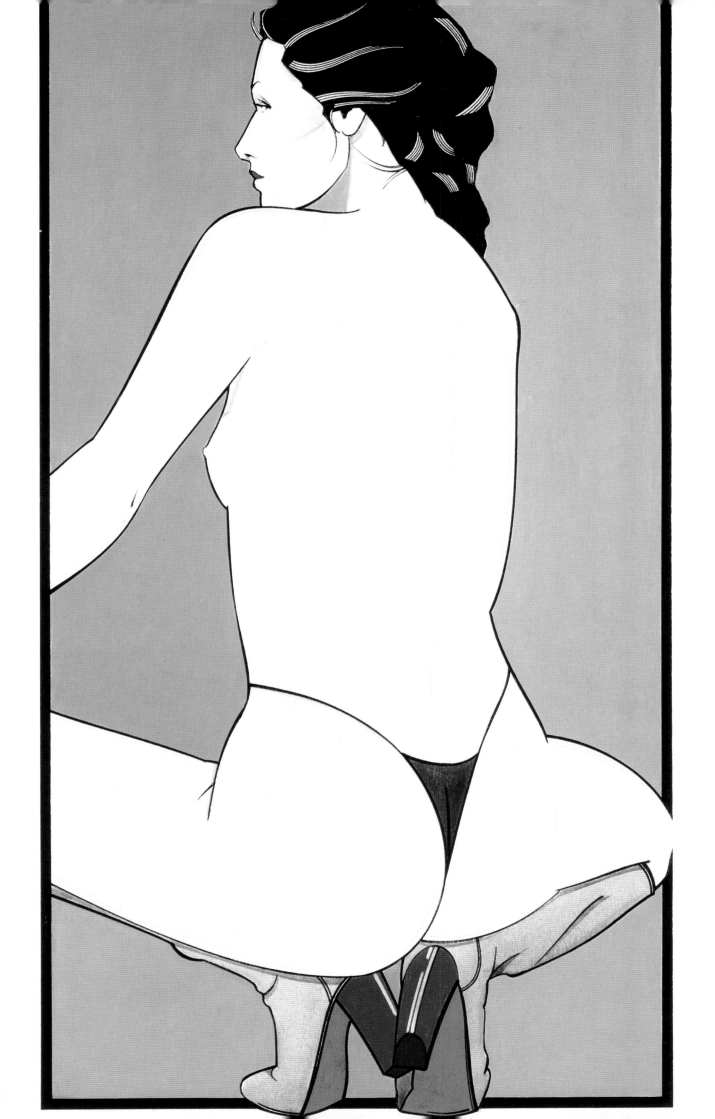

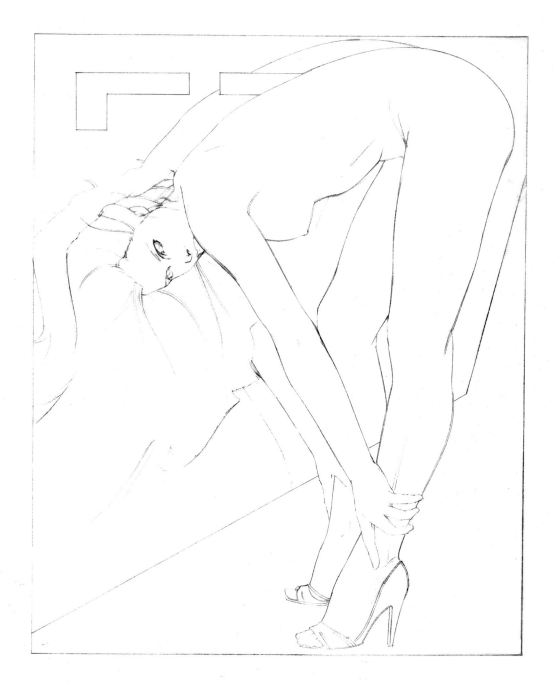

Untitled
Drawing

Untitled
Acrylic on board
Playboy illustration

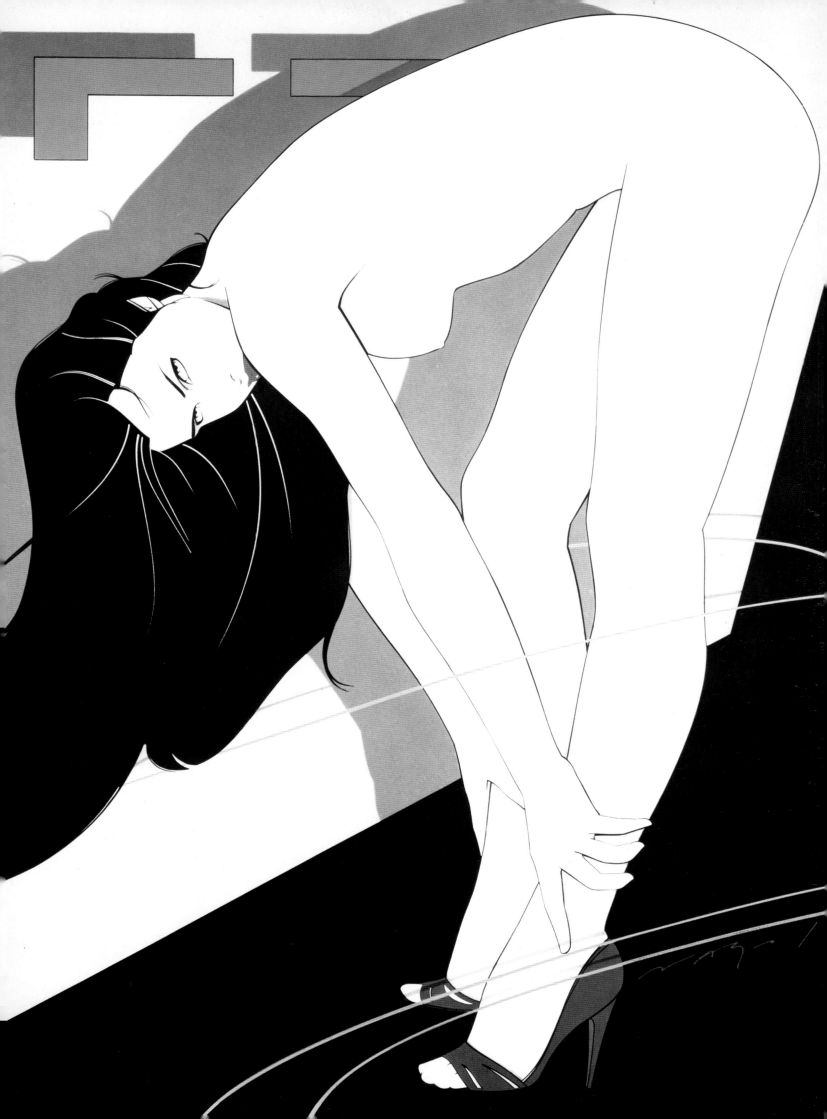

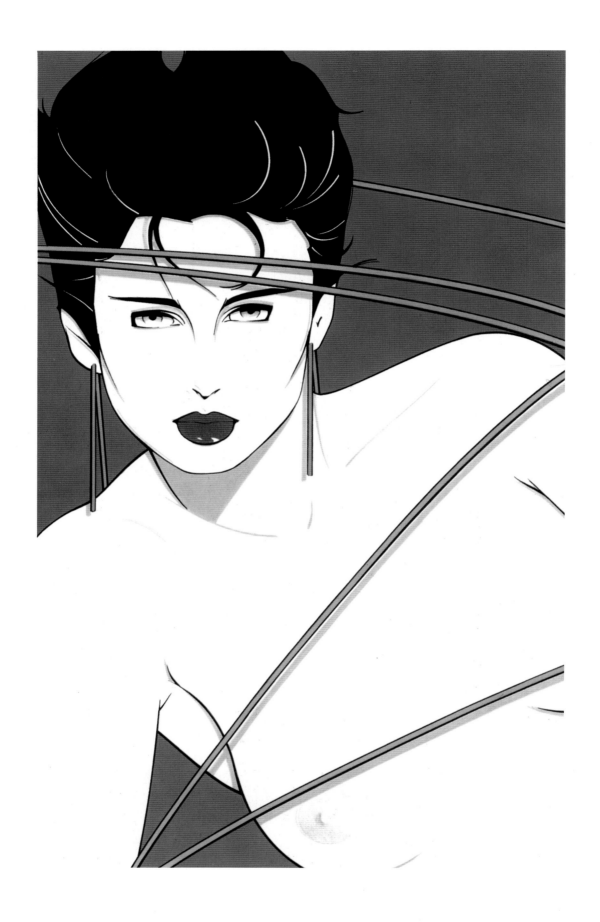

Untitled
Acrylic on board
Playboy illustration

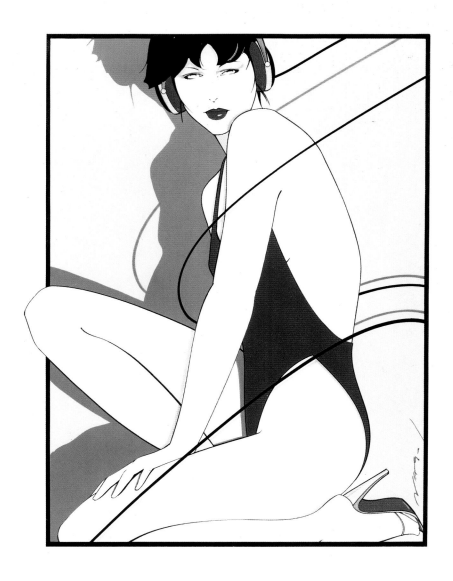

Untitled
Acrylic on board
Playboy illustration

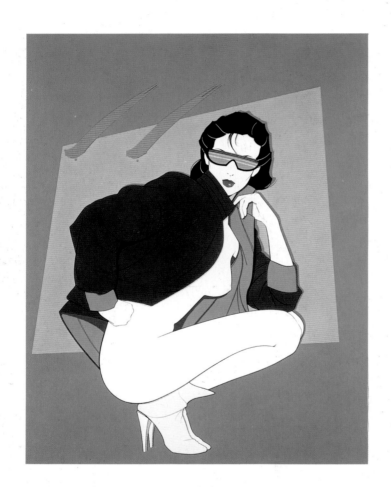

Untitled
Acrylic on board
Playboy illustration

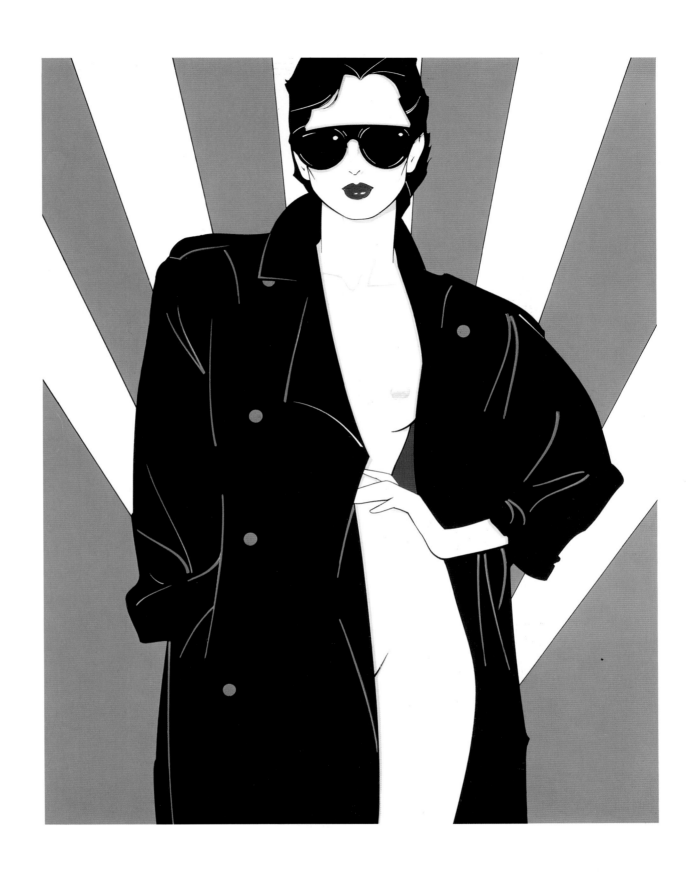

Untitled
Acrylic on board
Playboy illustration

Shades
Serigraph
Limited-edition poster

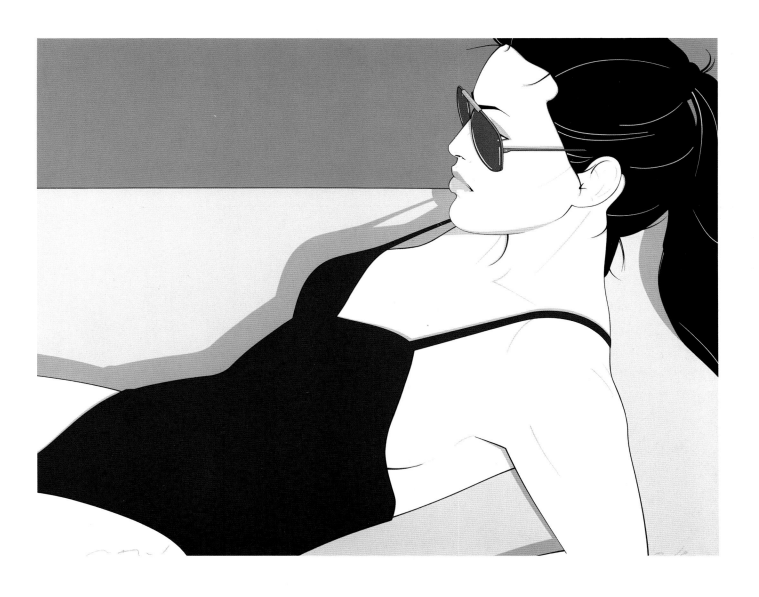

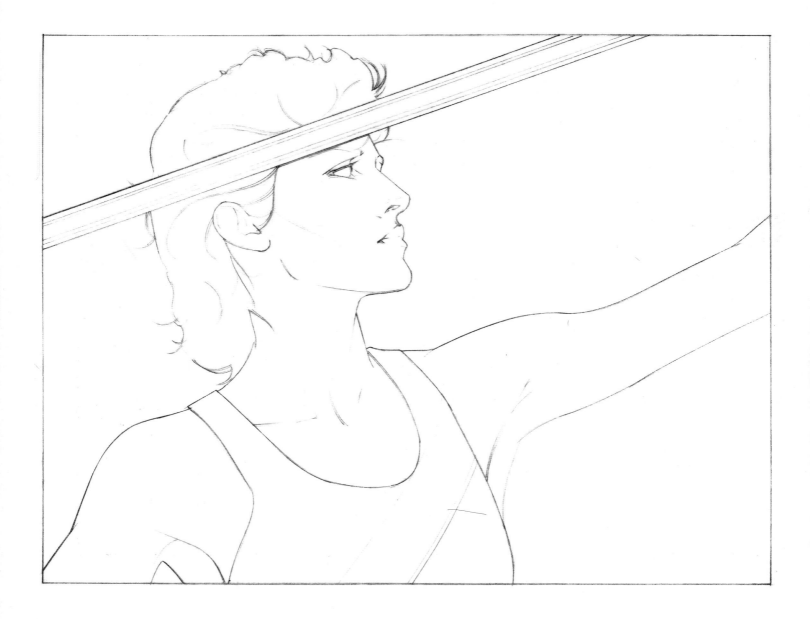

Untitled
Drawing (study for Olympics poster)

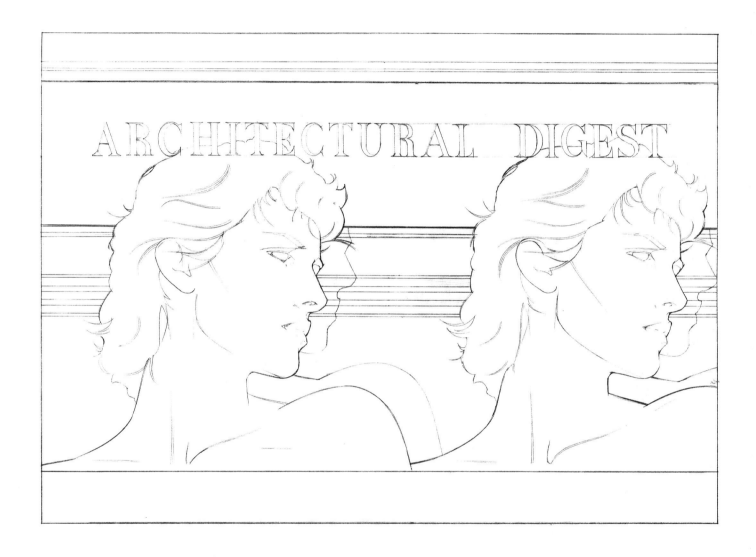

Architectural Digest
Drawing (study for poster)

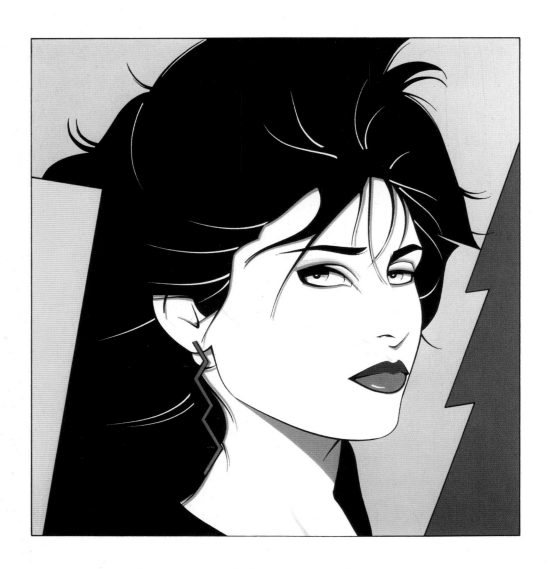

Untitled
Acrylic on canvas

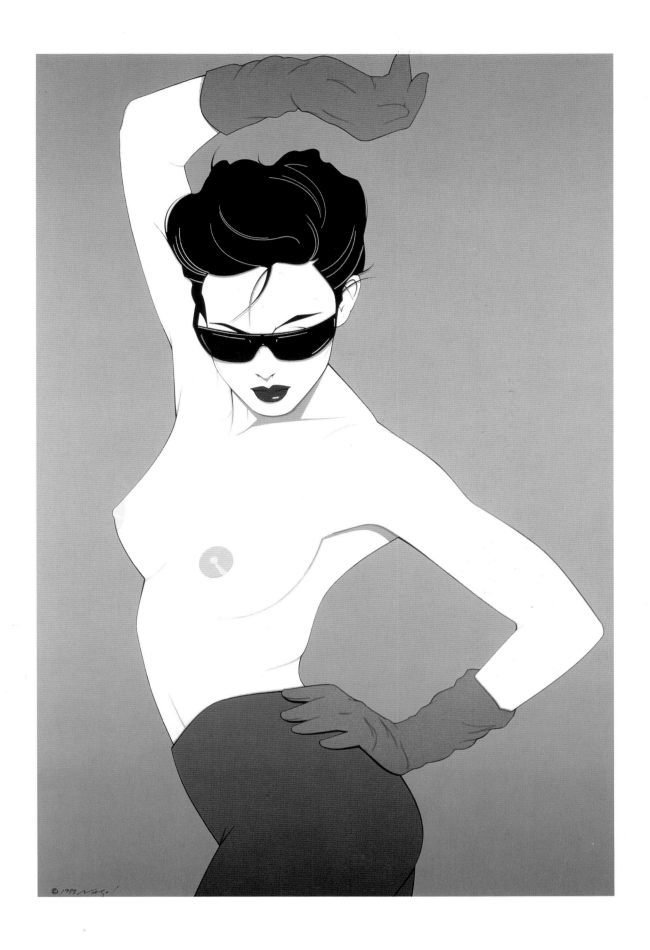

Untitled
Acrylic on canvas

Joan Collins
Serigraph
Limited-edition graphic

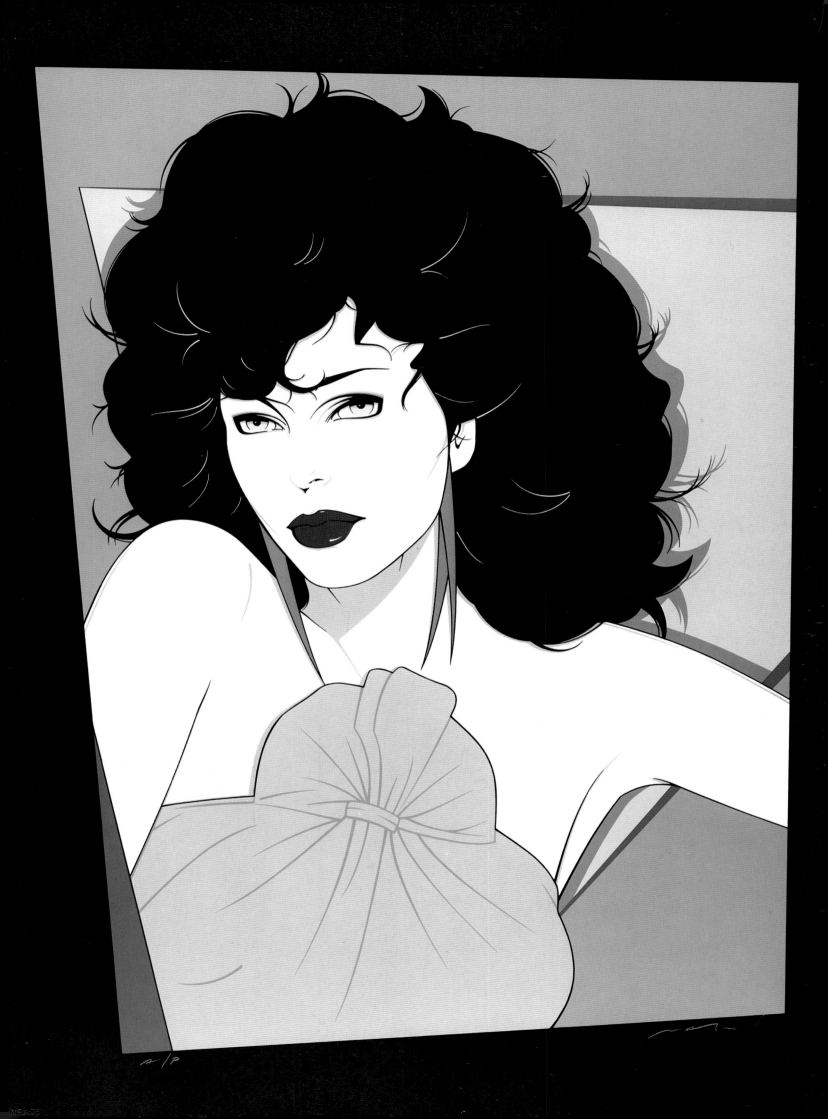

Michelle
Drawing

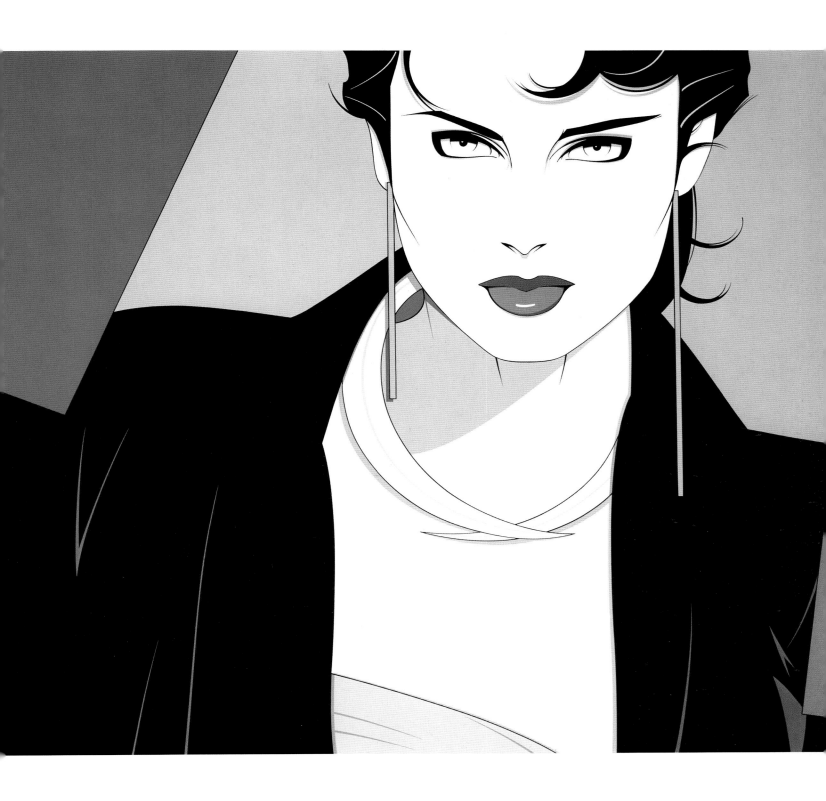

Michelle
Acrylic on canvas

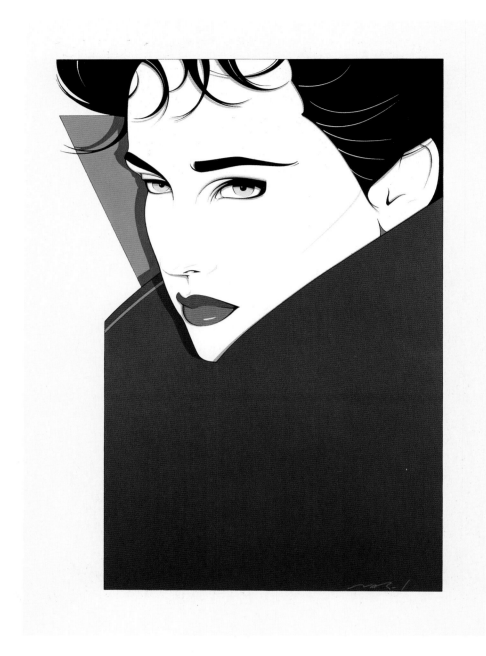

Untitled
Acrylic on canvas

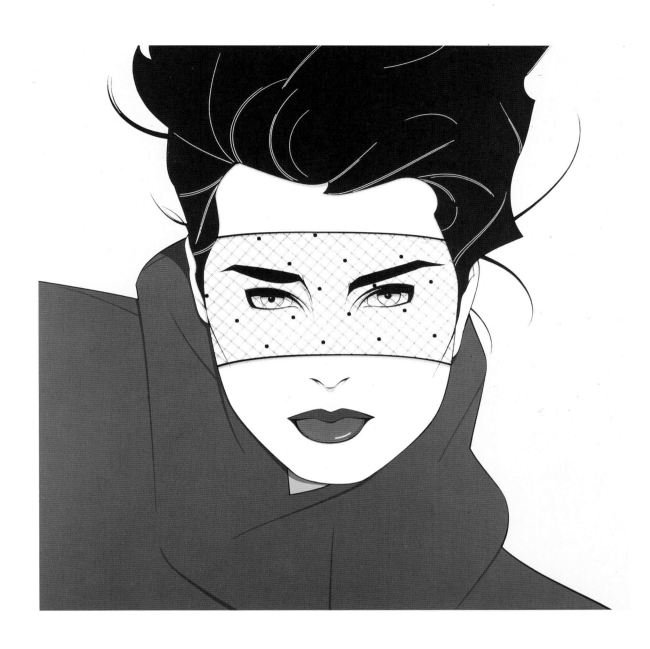

Brooke
Acrylic on canvas

Untitled
Acrylic on board
Lucky Strike ad campaign (Spain)

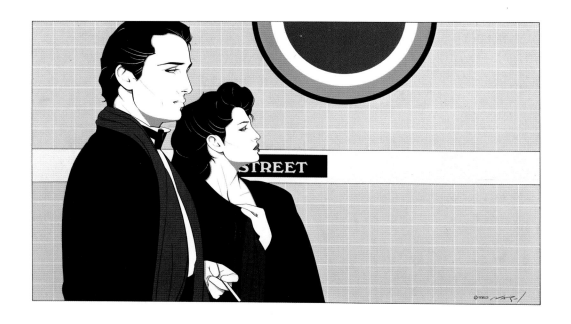

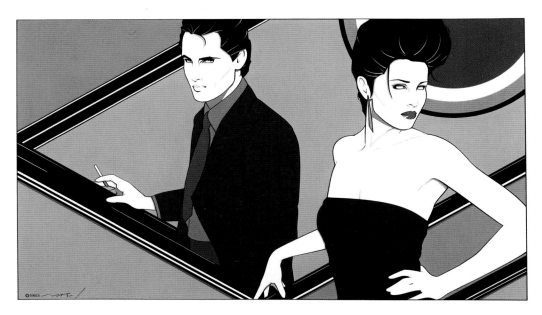

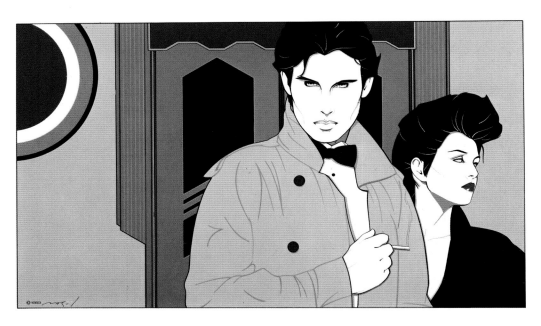

Untitled
Acrylic on board
Playboy illustration

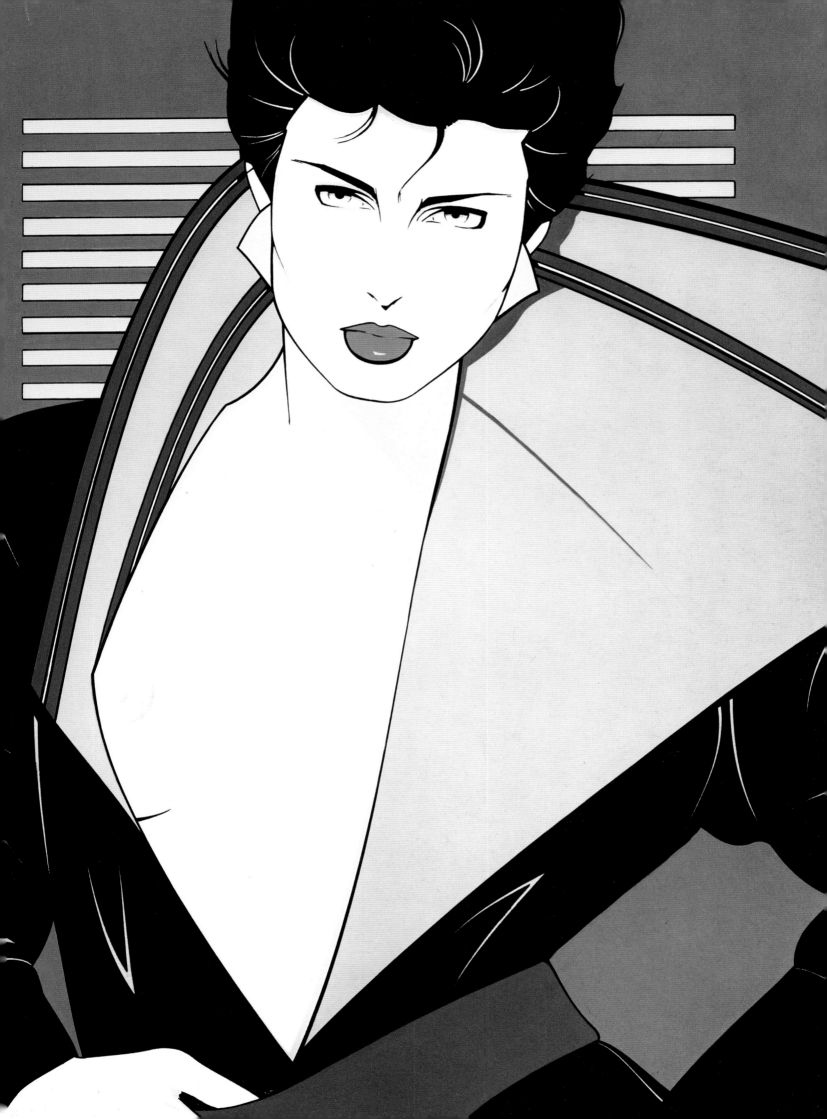

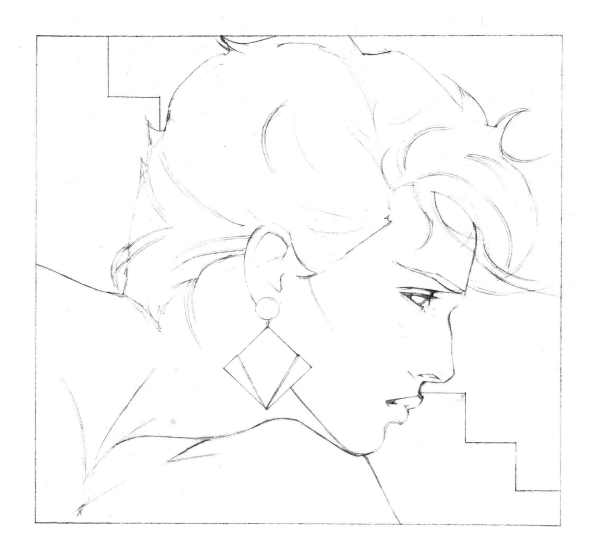

Untitled
Drawing

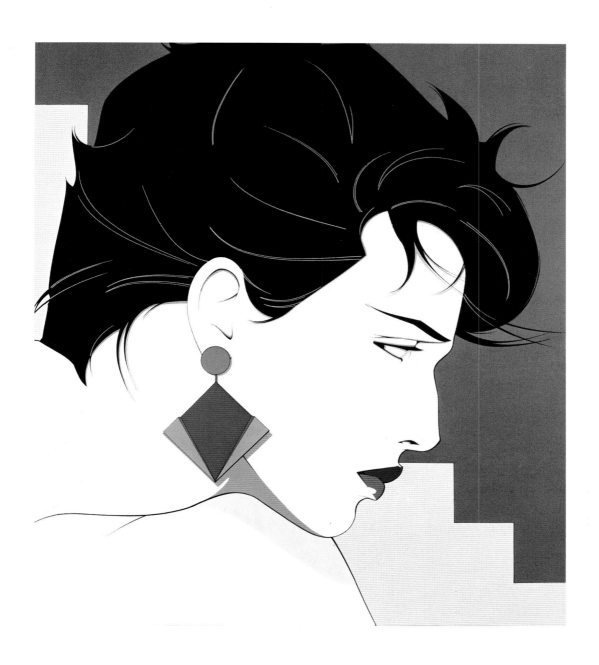

Untitled
Acrylic on canvas

Untitled
Acrylic on board
Playboy illustration

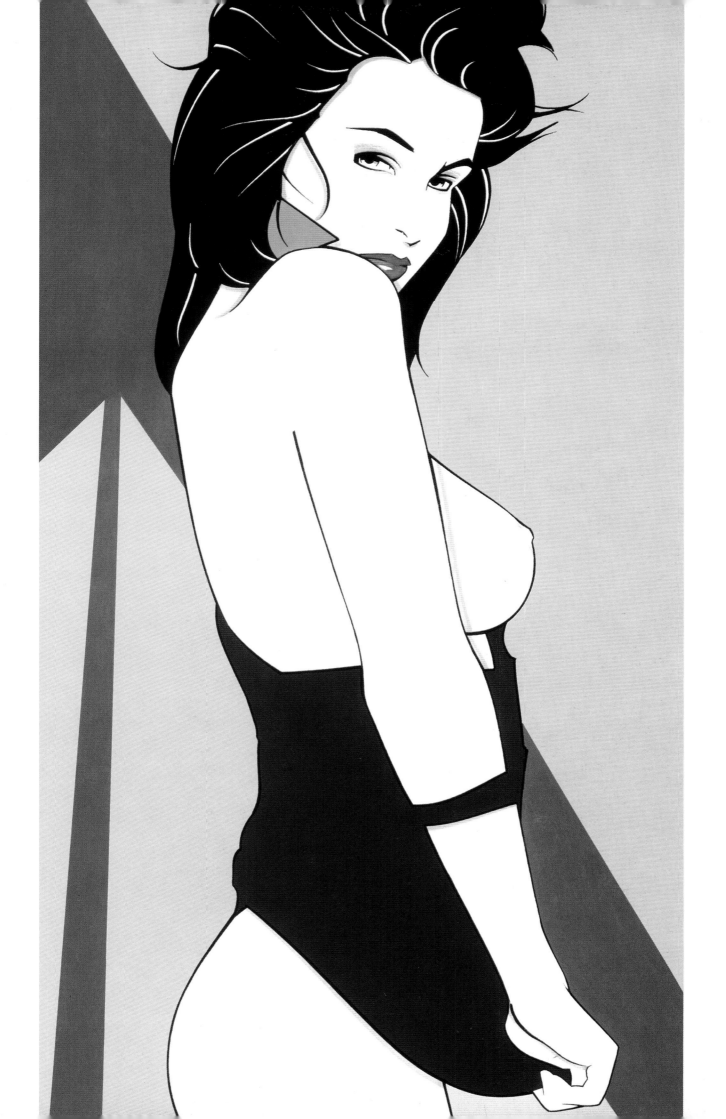

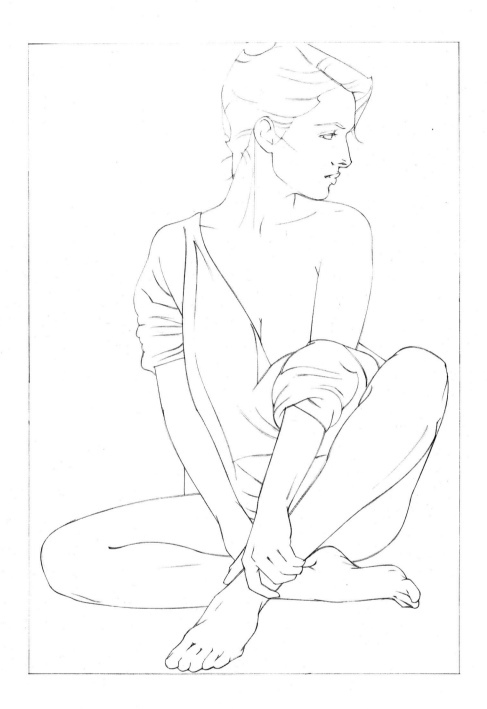

Untitled
Drawing

Untitled
Acrylic on canvas

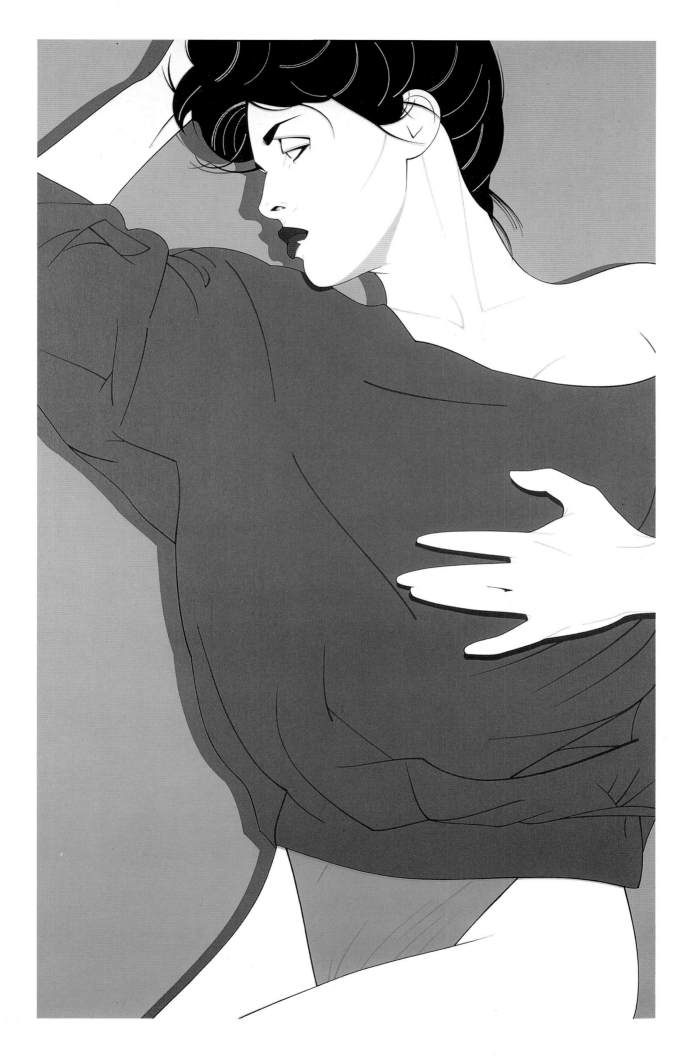

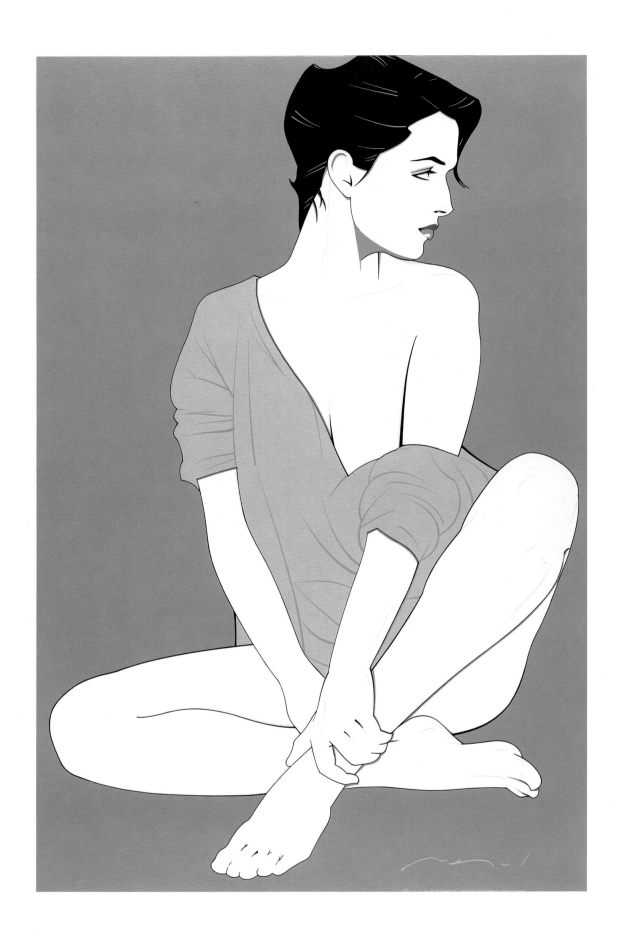

Untitled
Acrylic on canvas

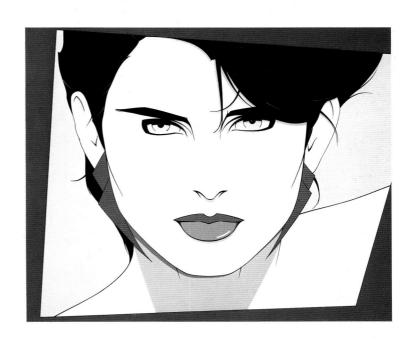

Cleo
Acrylic on canvas

Untitled
Drawing

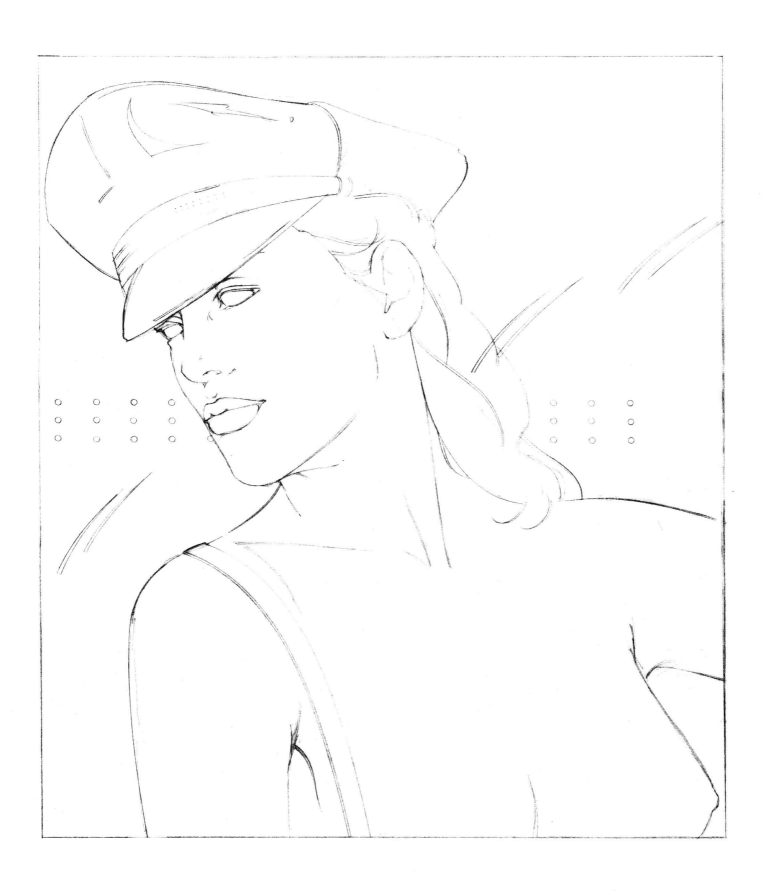

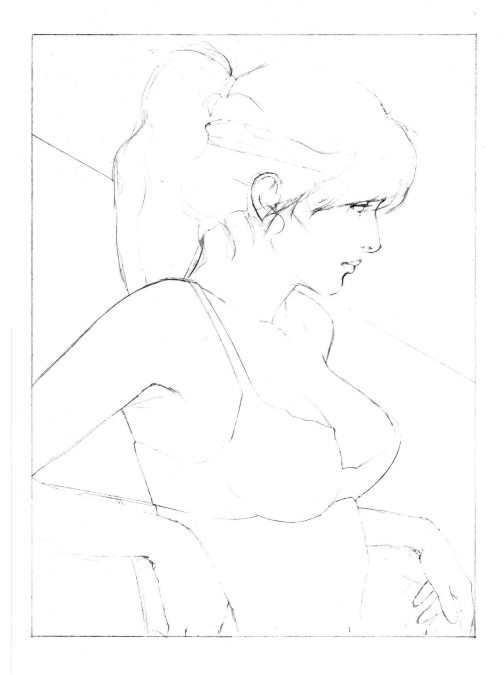

Untitled
Drawing

Untitled
Acrylic on board
Playboy illustration

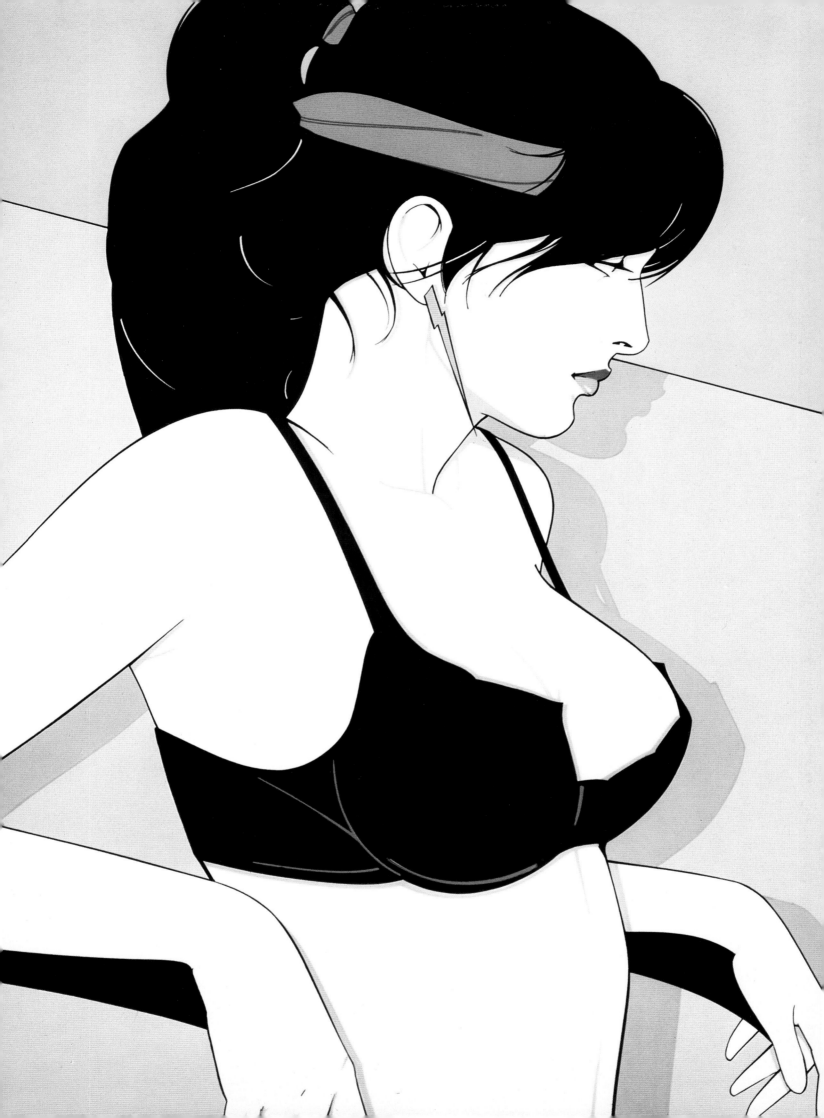

Grunwald Center for the Graphic Arts. Serigraph progressive set

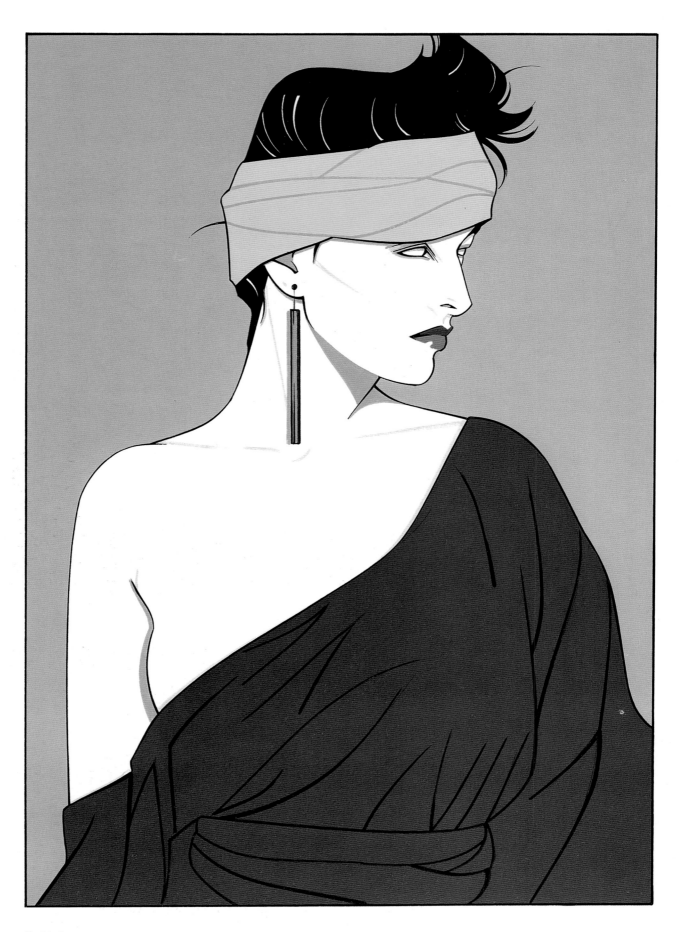

Untitled
Acrylic on canvas

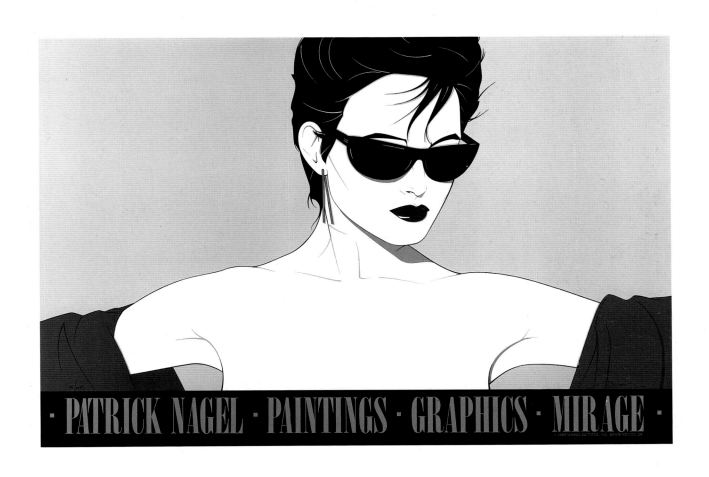

Sunglasses
Solid-plate lithography with foil stamping
Poster

Untitled
Drawing

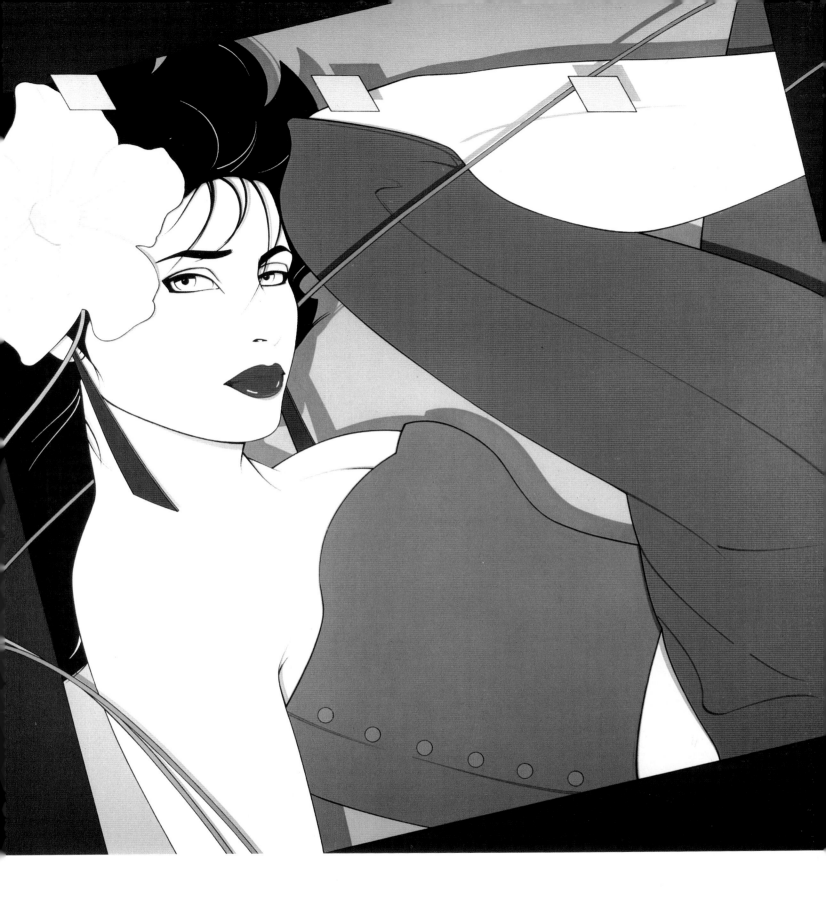

Untitled
Acrylic on canvas
Duran Duran record sleeve (Japan)

Mask
Serigraph
Limited-edition graphic

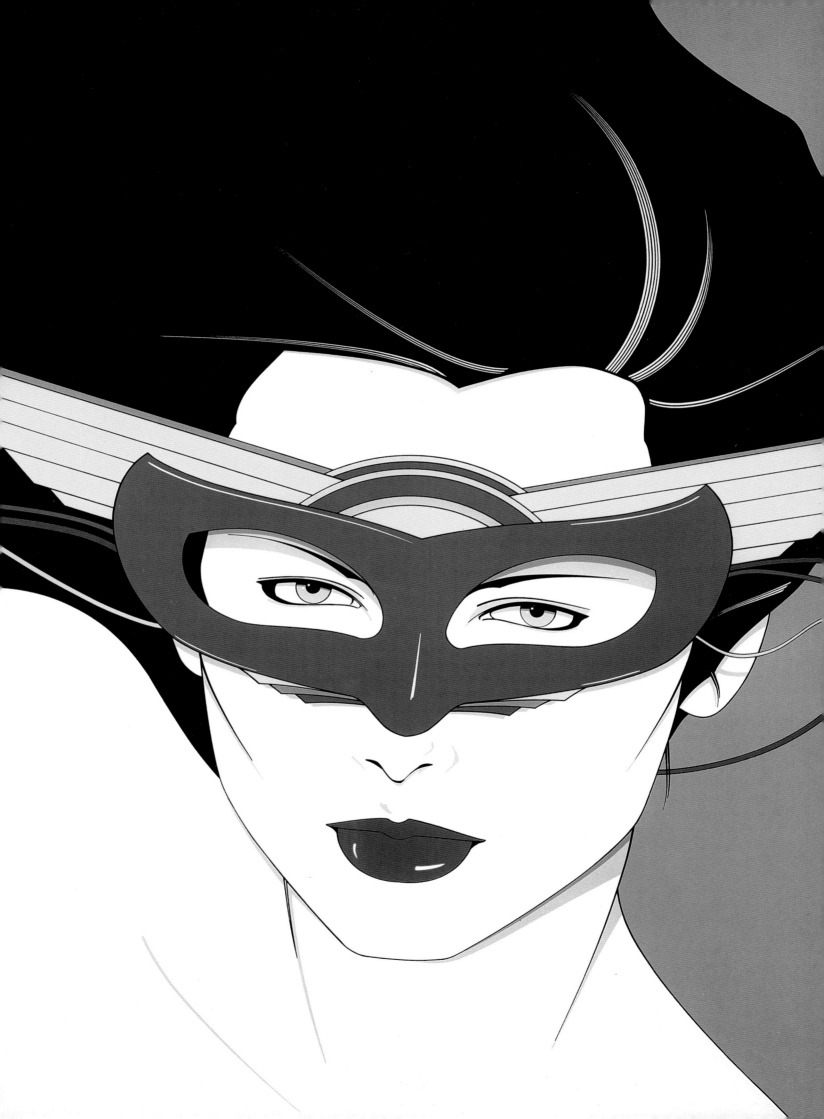

Untitled
Drawing

Untitled
Acrylic on canvas

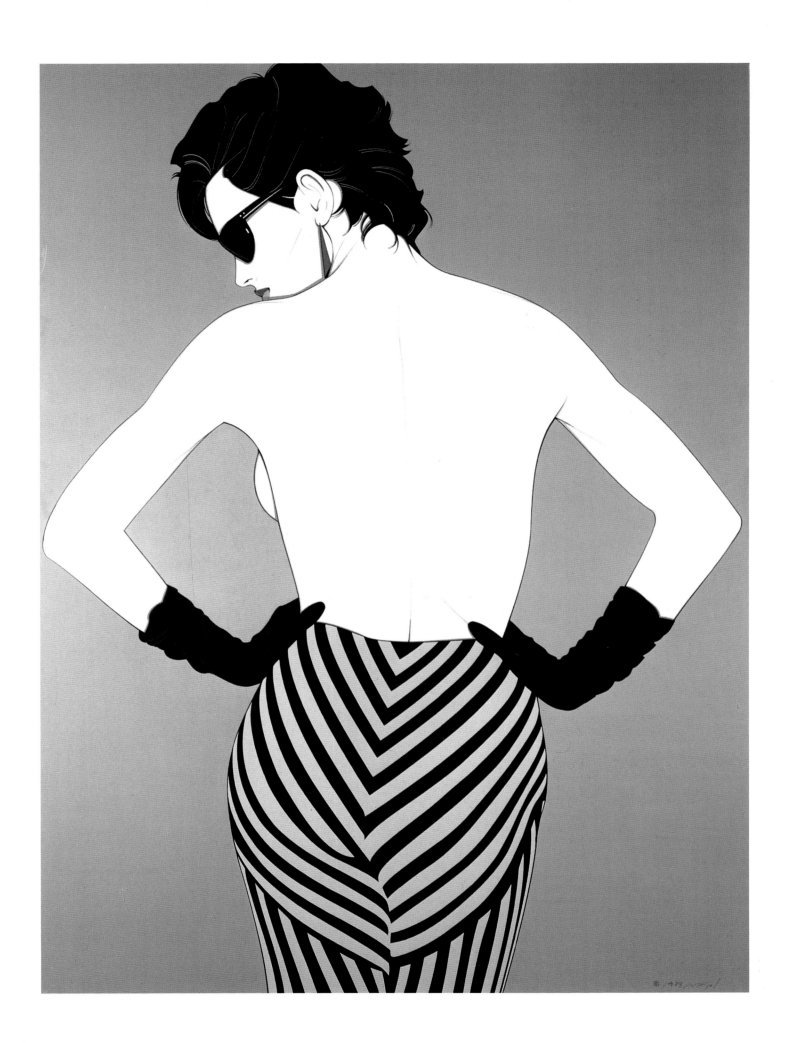

103

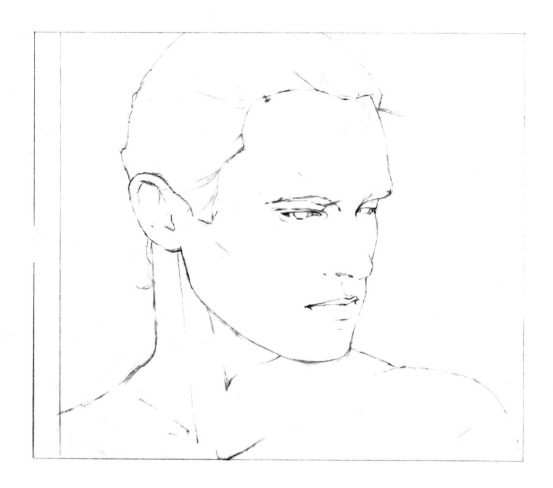

Untitled
Drawing

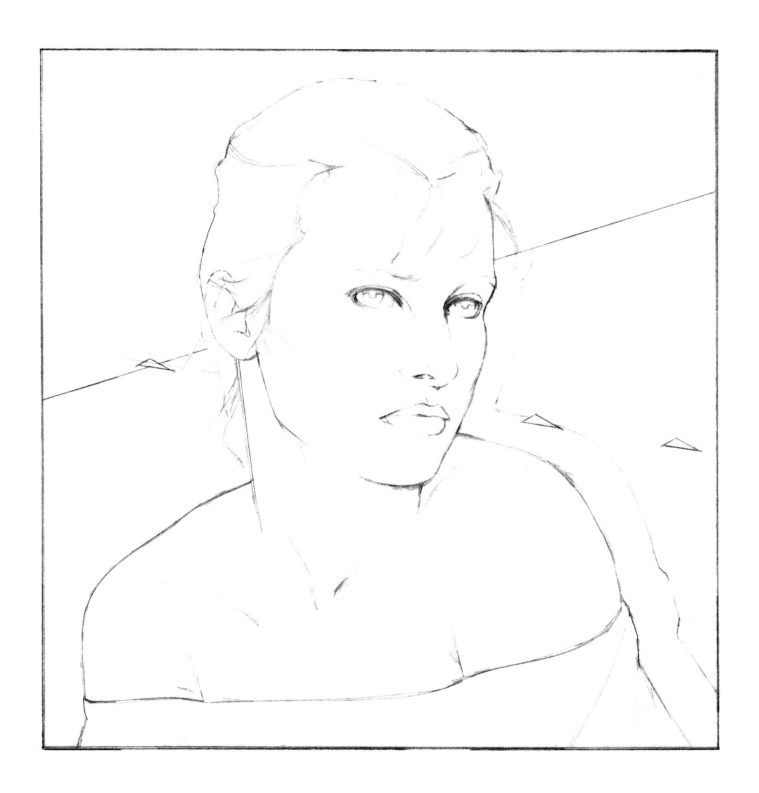

Michele
Drawing

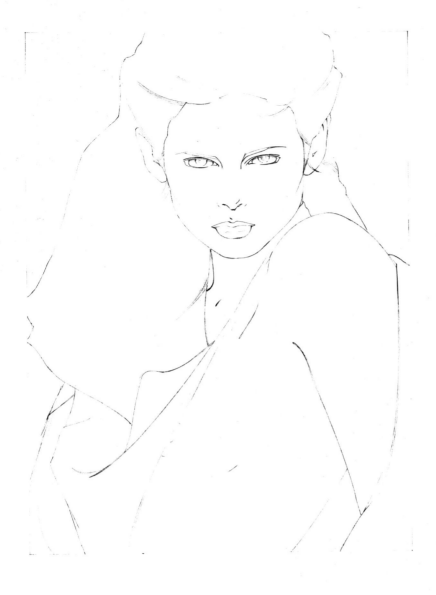

Mirage
Drawing

Mirage
Acrylic on canvas

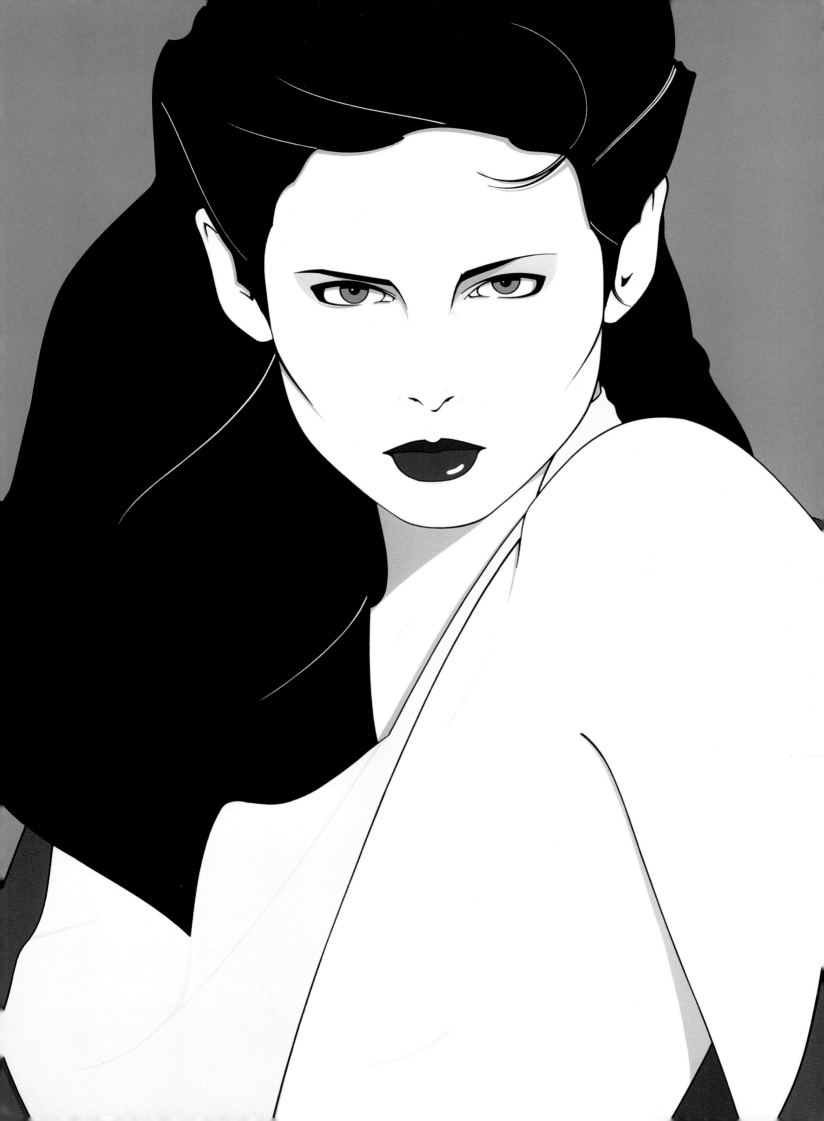

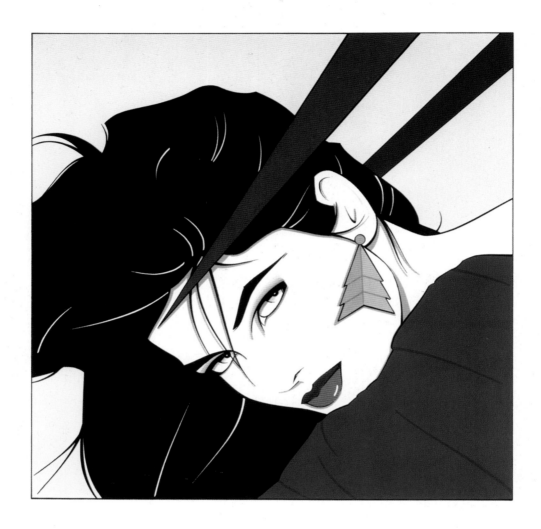

Untitled
Acrylic on canvas

Untitled
Acrylic on board
Playboy illustration

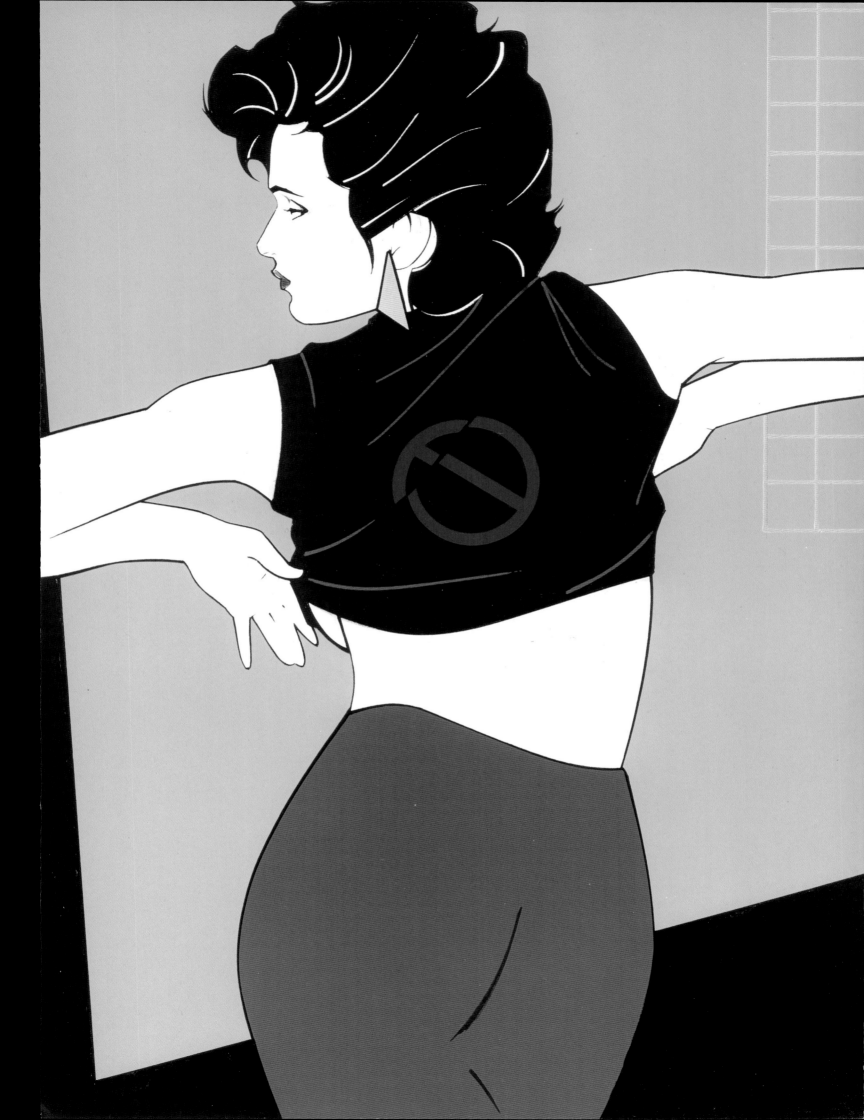

Rio
Drawing

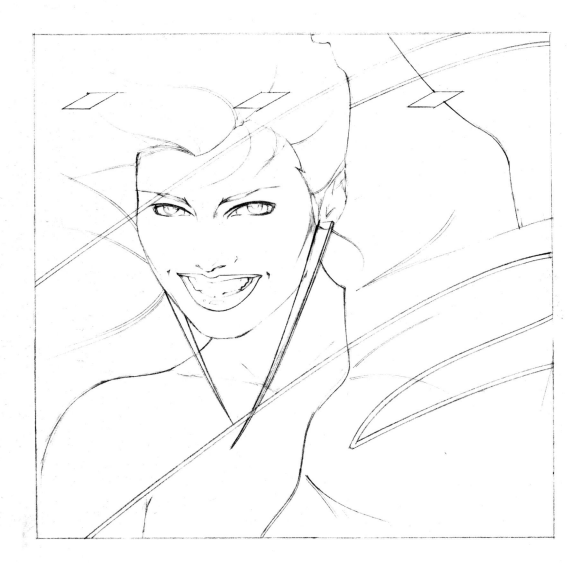

Rio
Acrylic on canvas
Duran Duran album cover

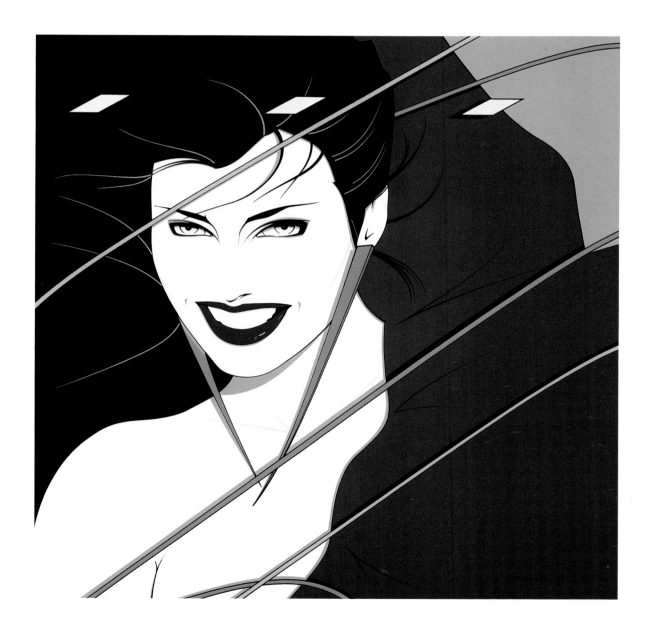

Untitled
Acrylic on canvas

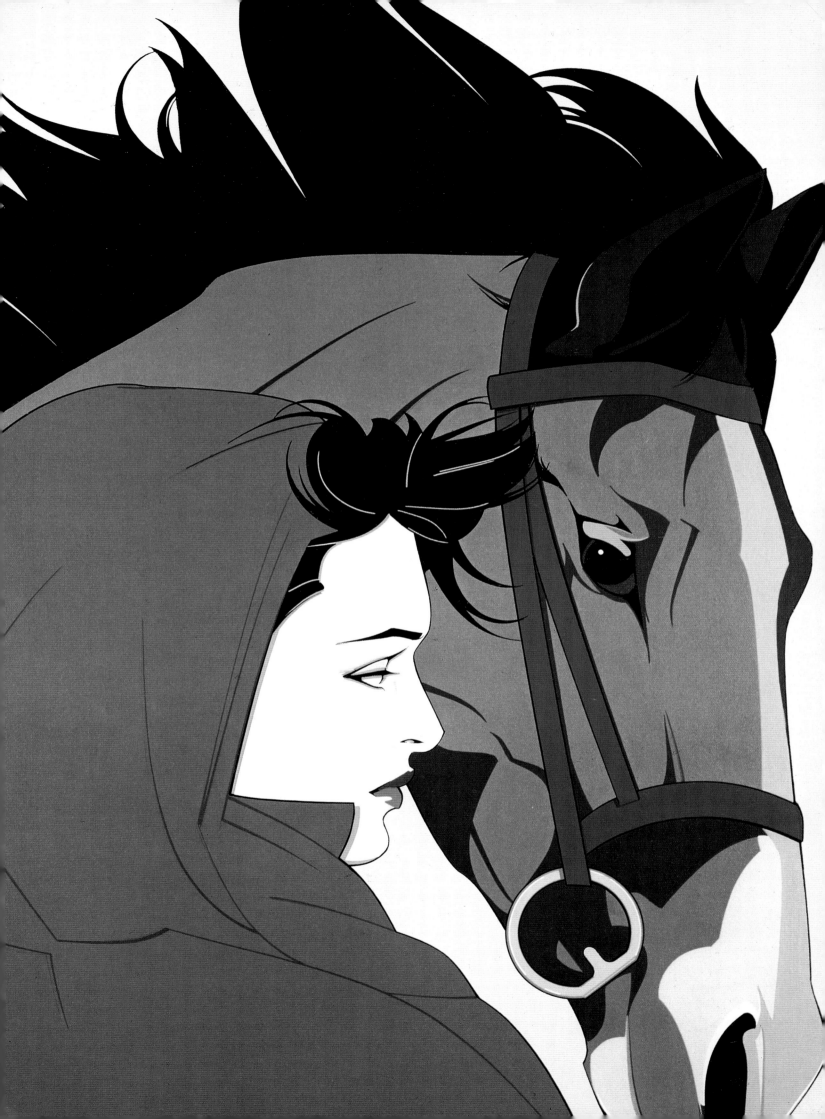

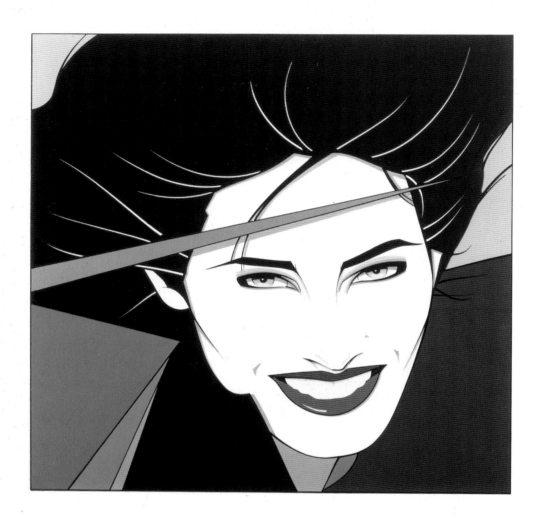

Untitled
Acrylic on board
Playboy illustration

Untitled
Acrylic on canvas

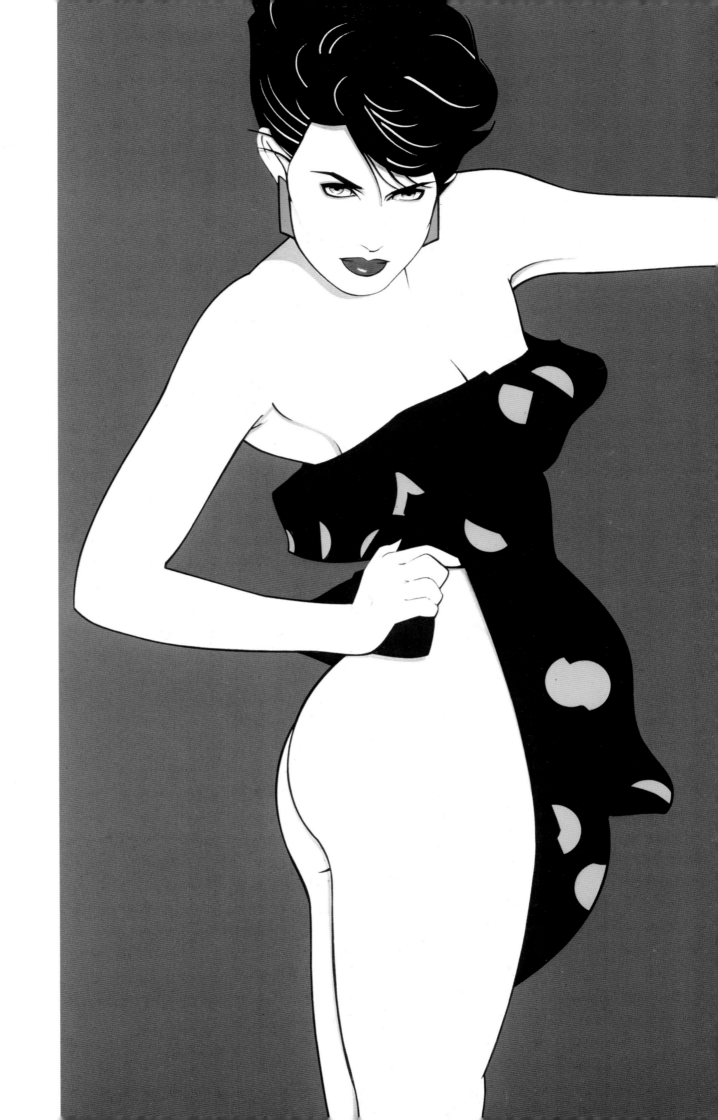

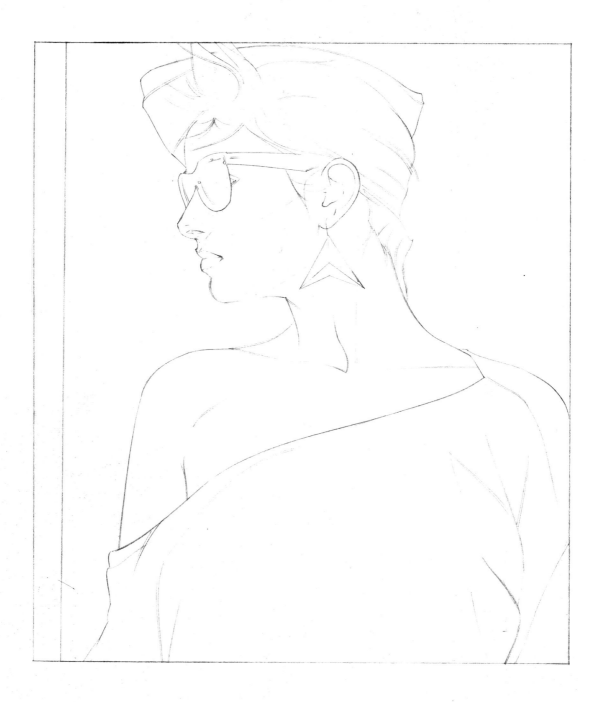

Carol
Drawing

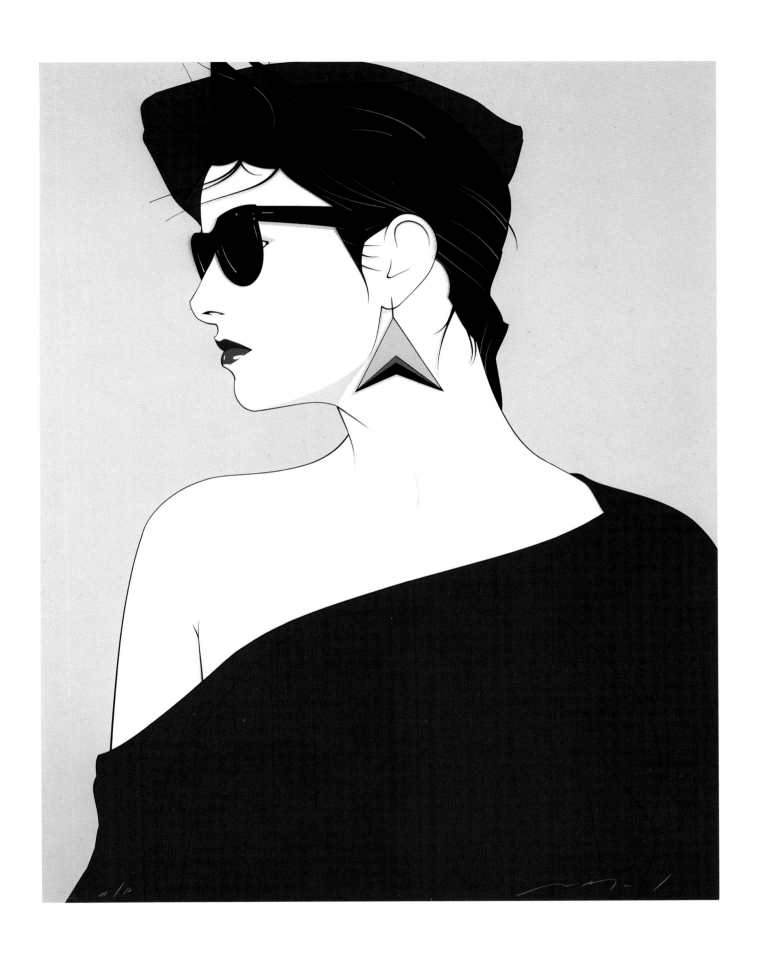

Carol
Serigraph
Limited-edition graphic

Untitled
Acrylic on board
Playboy illustration

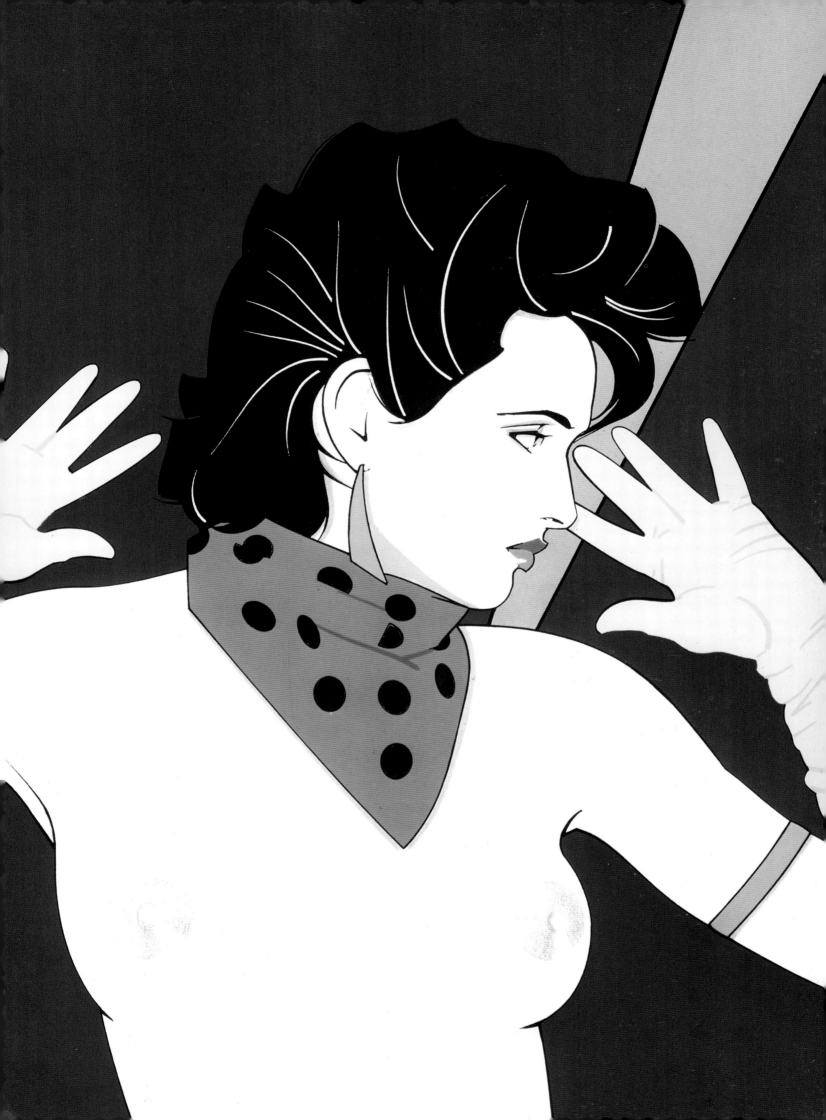

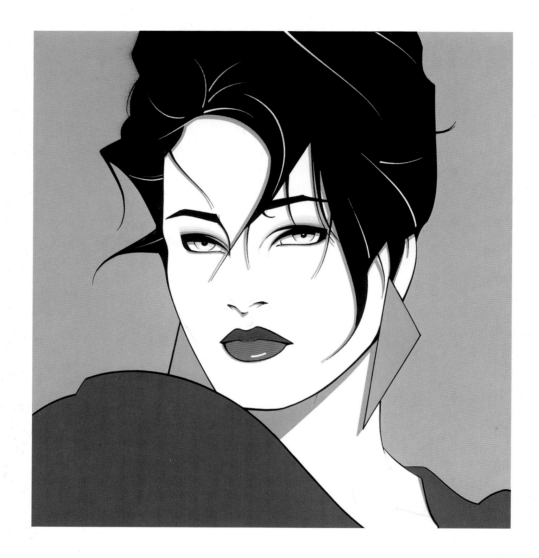

Untitled
Acrylic on canvas

Untitled
Acrylic on board
Playboy illustration

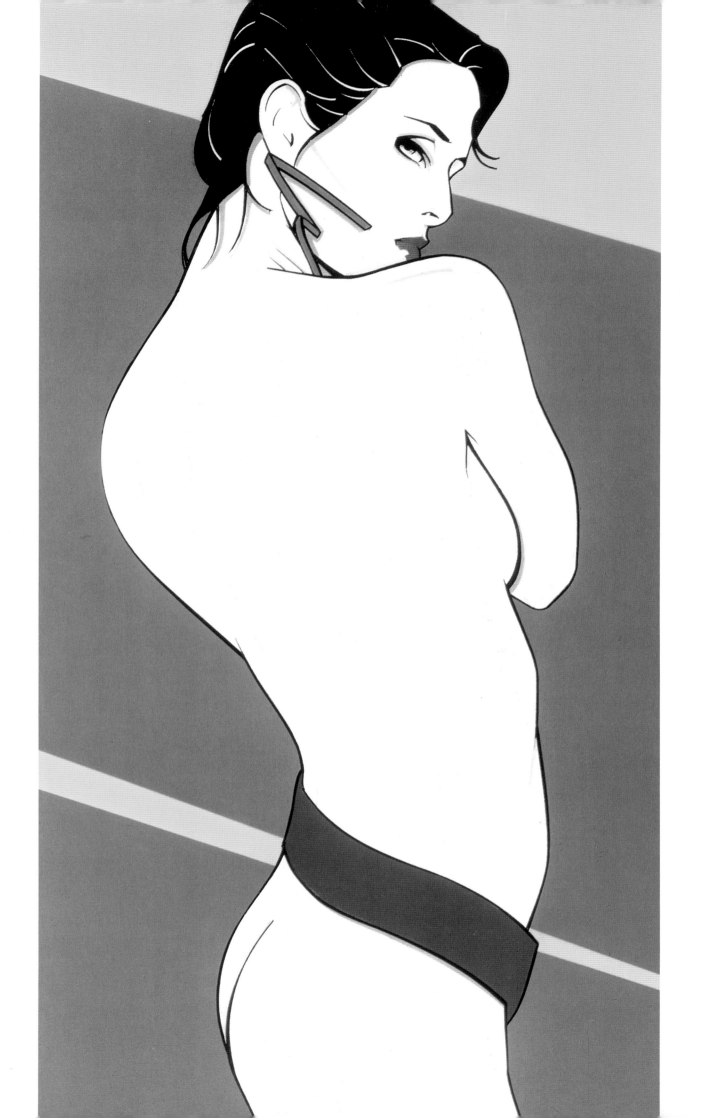

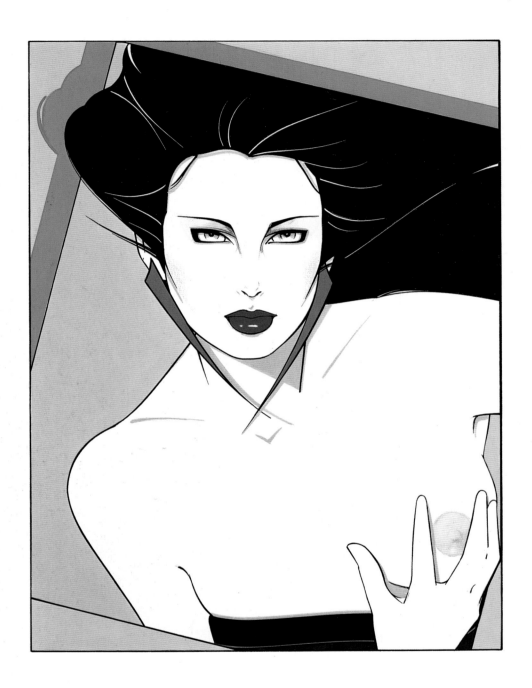

Untitled
Acrylic on board
Playboy illustration

Untitled
Acrylic on canvas

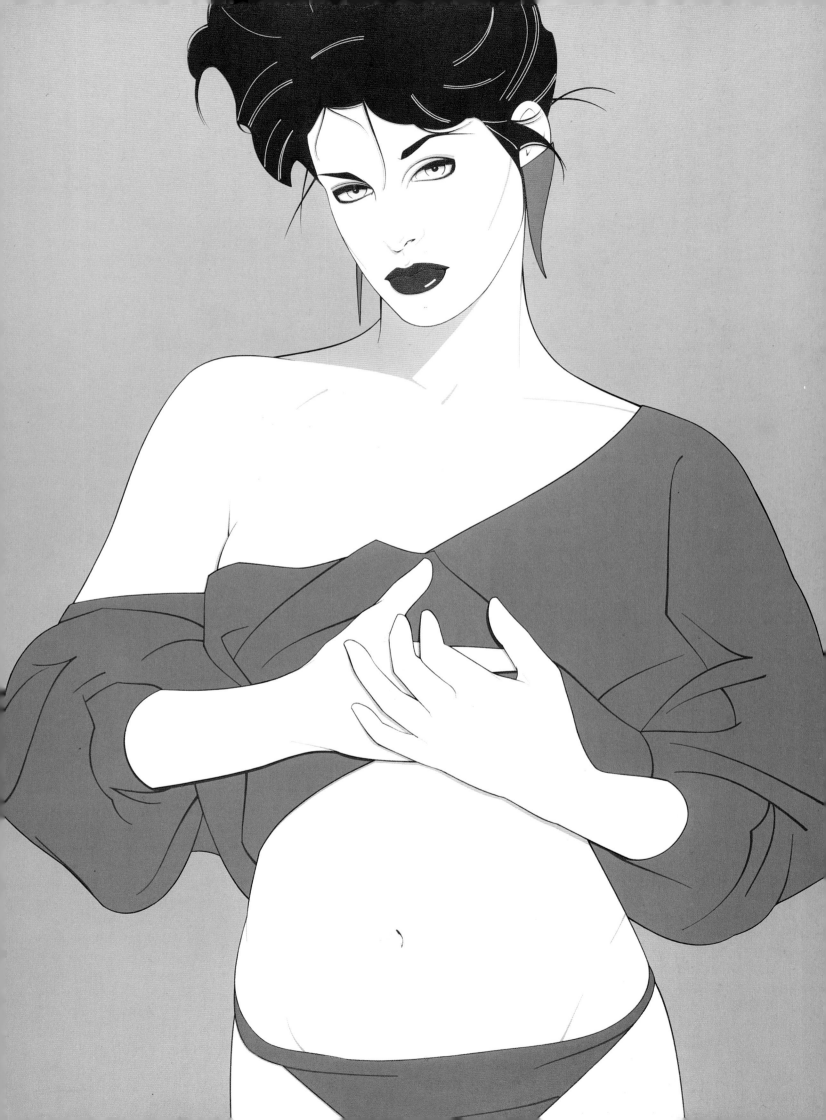

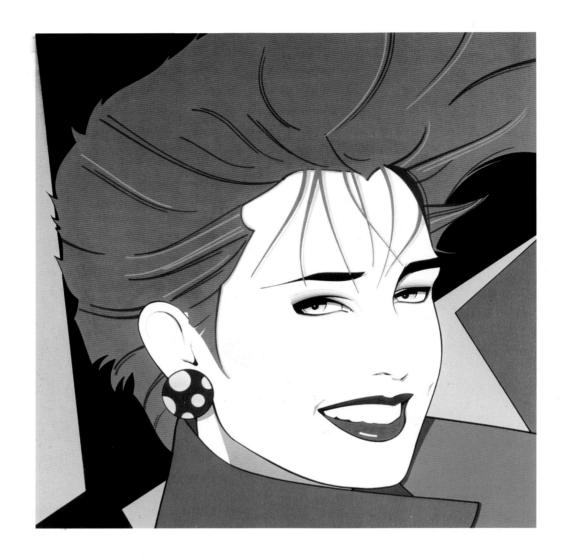

Untitled
Acrylic on board
Playboy illustration

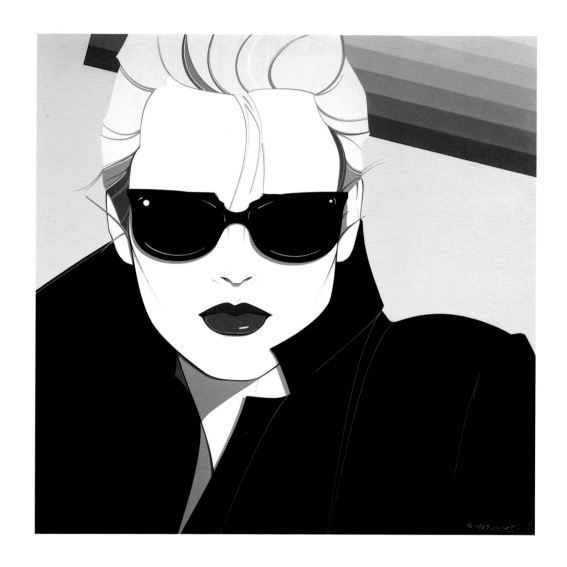

Untitled
Acrylic on canvas

Piedmont Graphics (detail)
Serigraph
Limited-edition poster

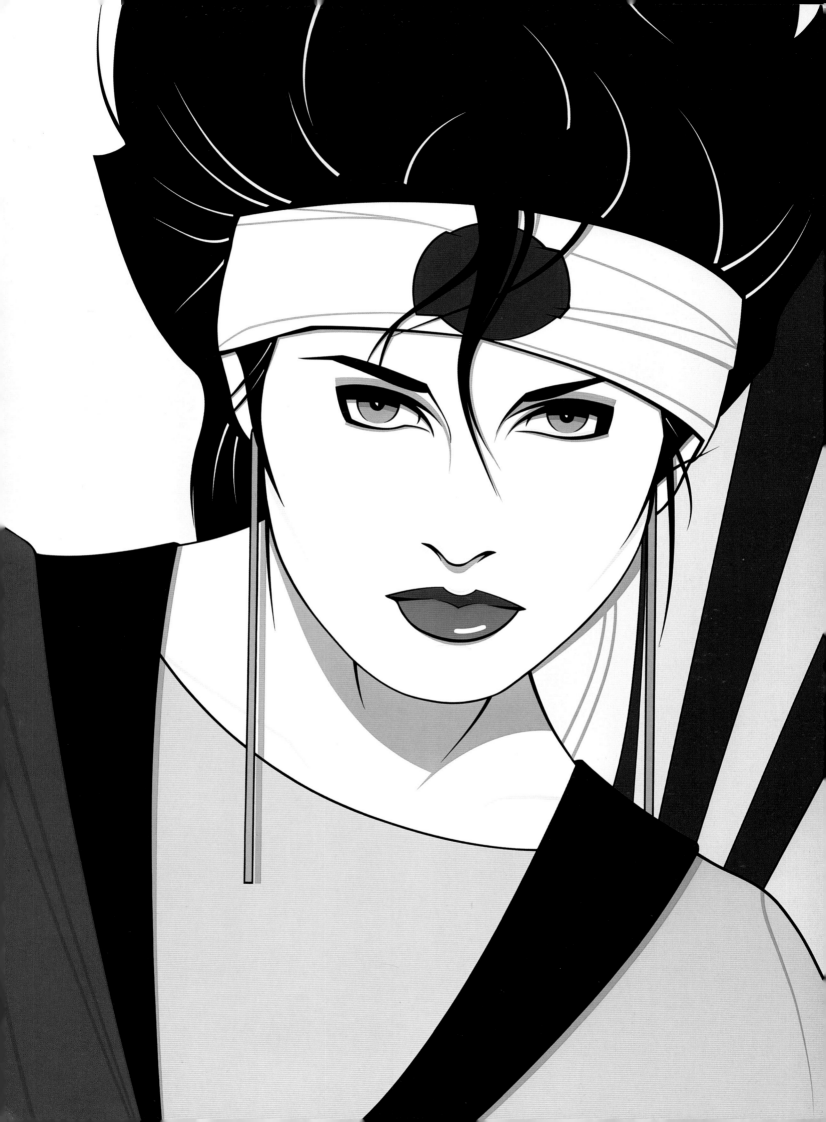

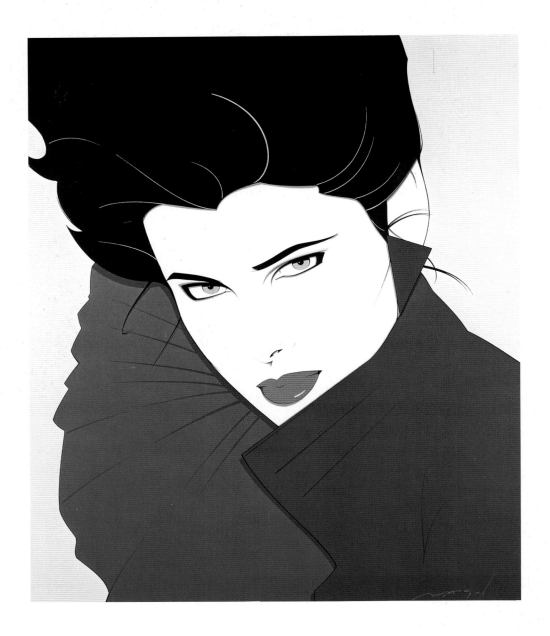

Untitled
Acrylic on canvas

Untitled
Acrylic on board
Playboy illustration

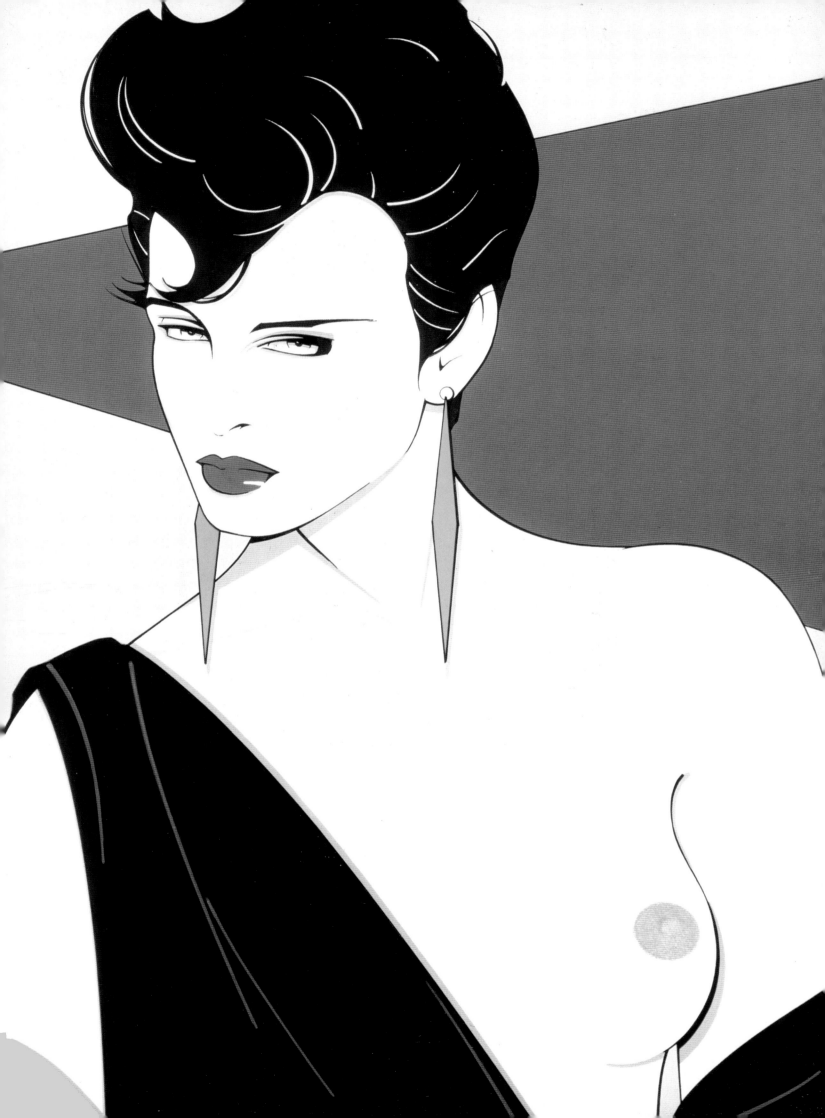

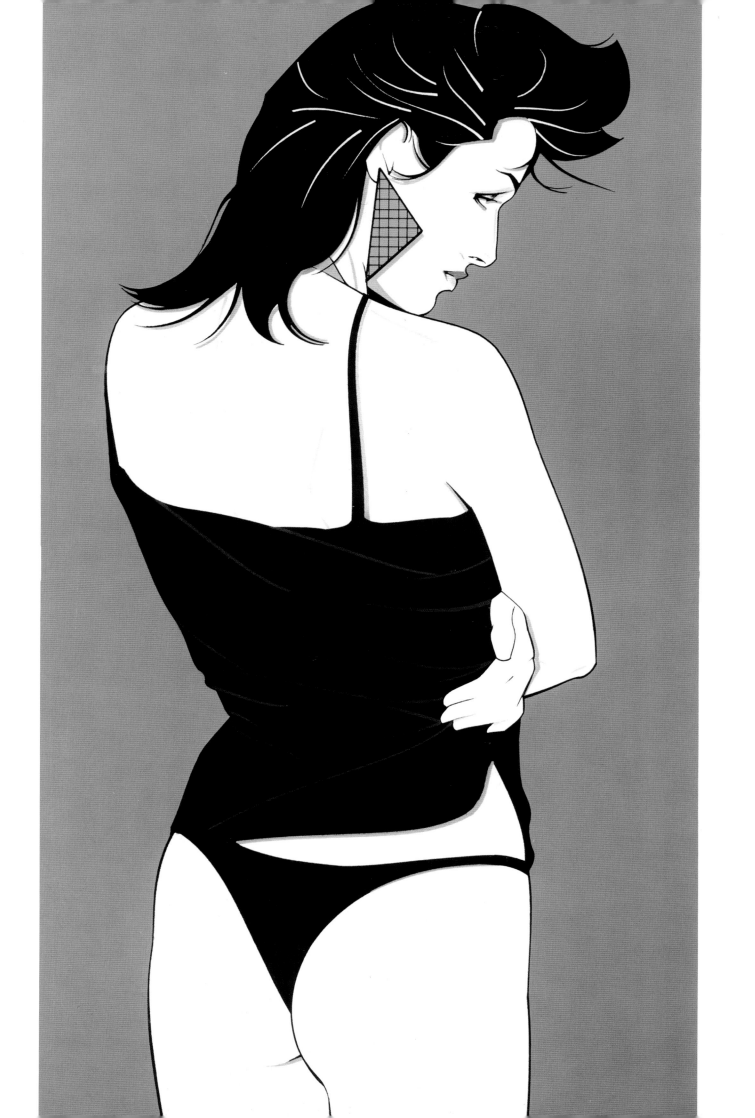

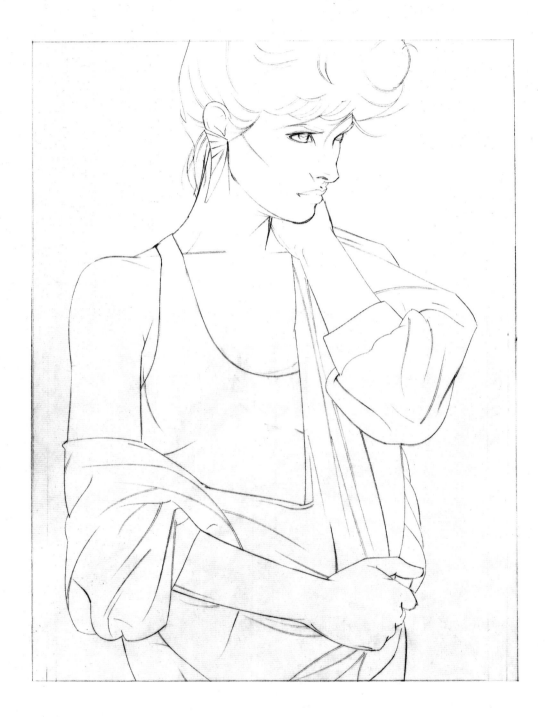

Untitled
Drawing

Untitled
Acrylic on canvas

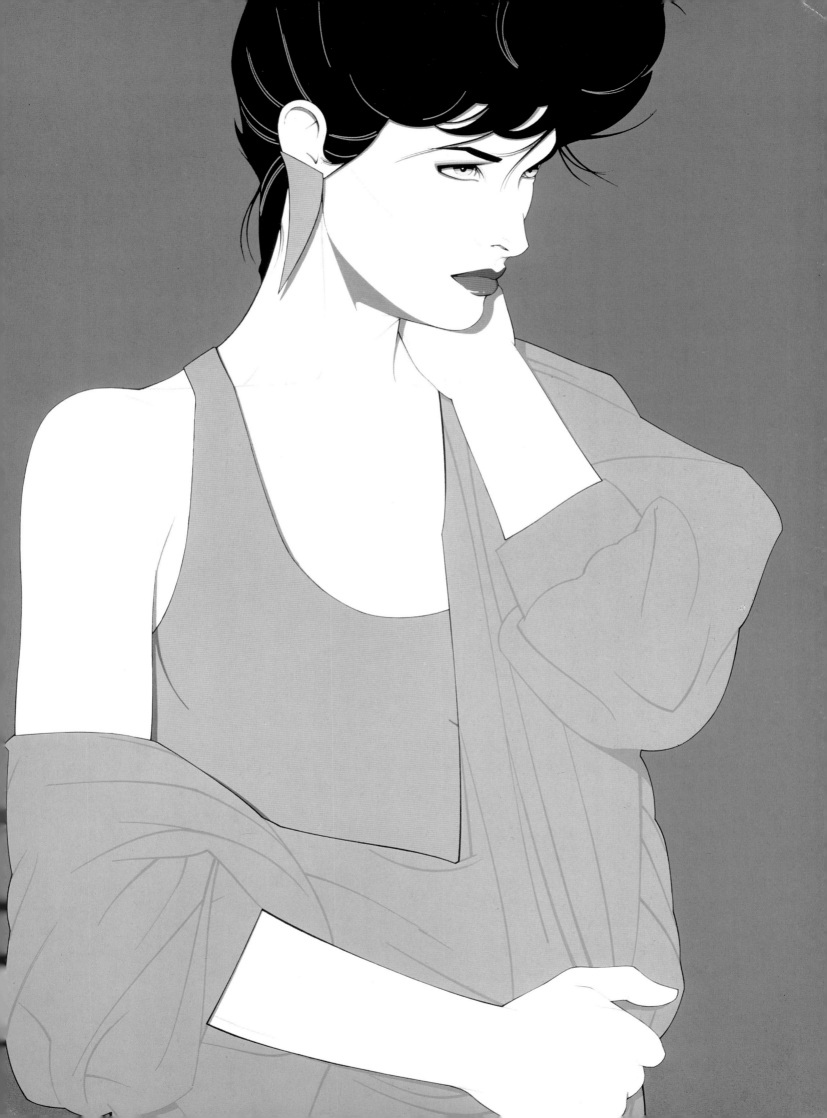

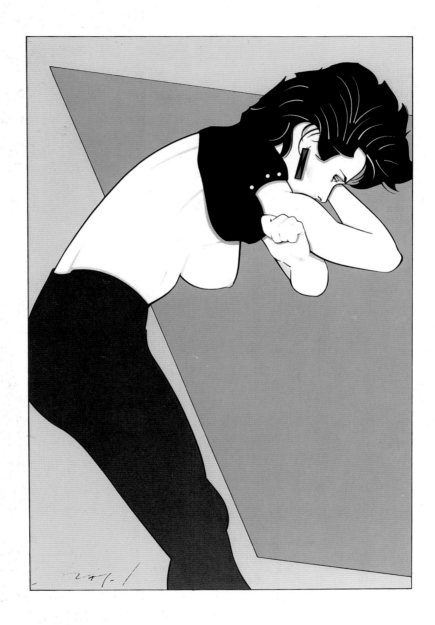

Untitled
Acrylic on board
Playboy illustration

Untitled
Acrylic on canvas

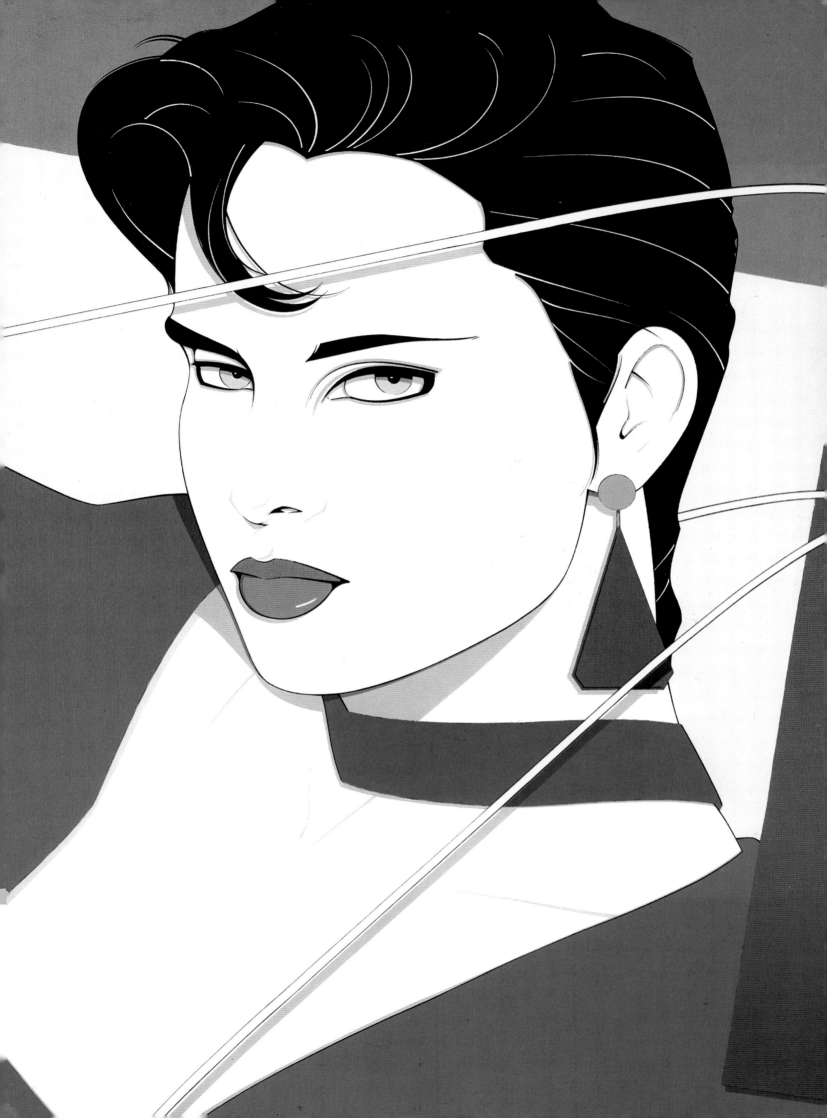

Untitled
Acrylic on board
Playboy illustration

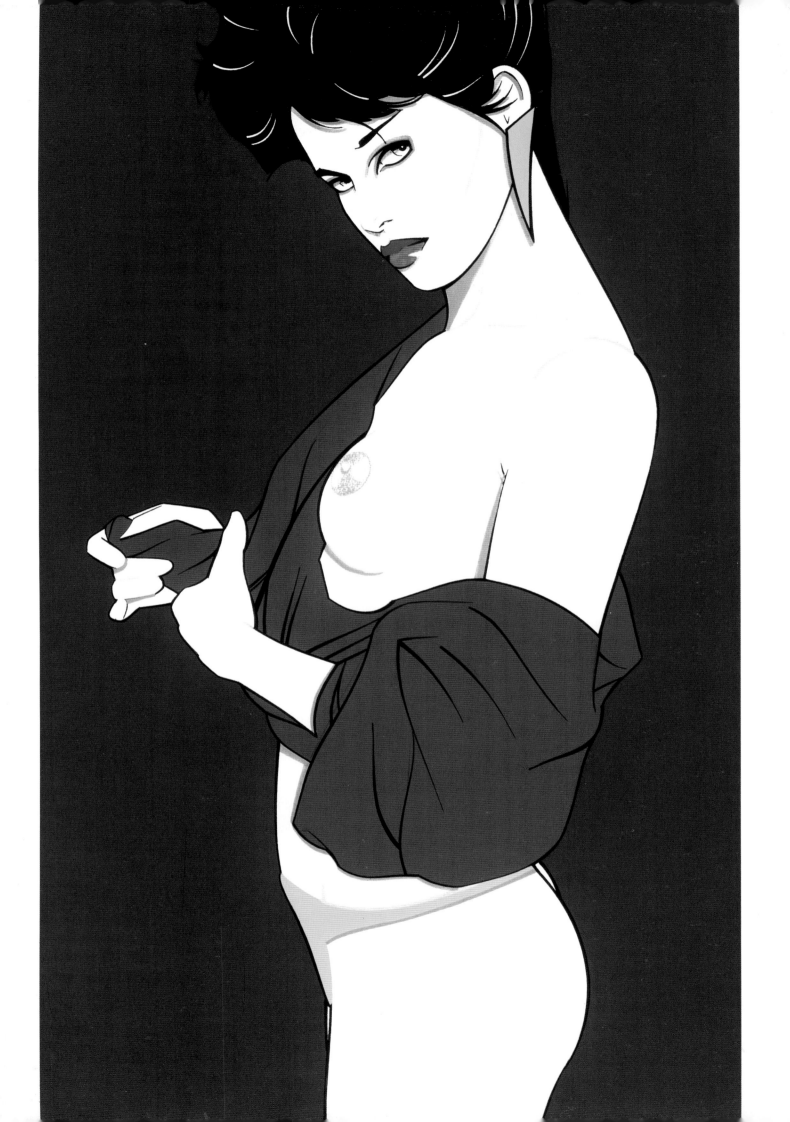

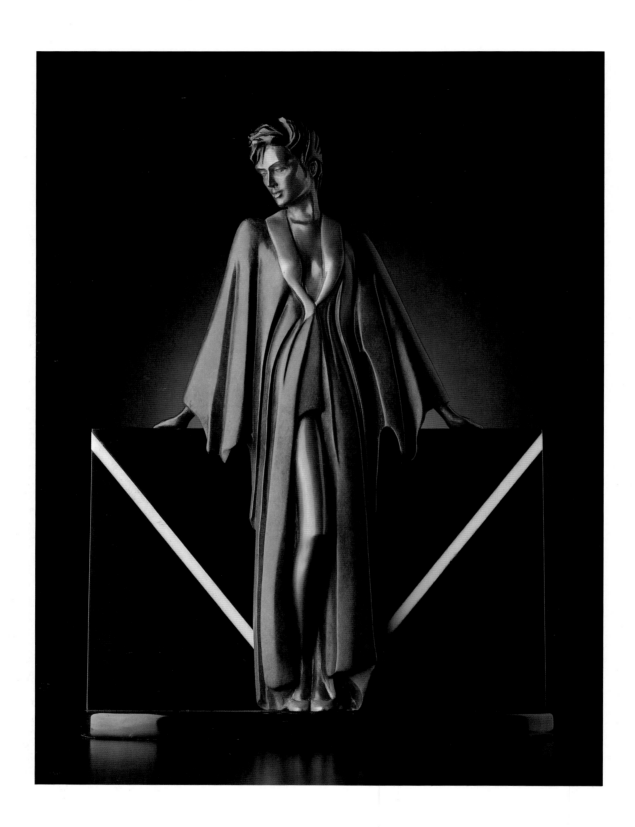

Standing Lady
Bronze, marble, multicolored
patina

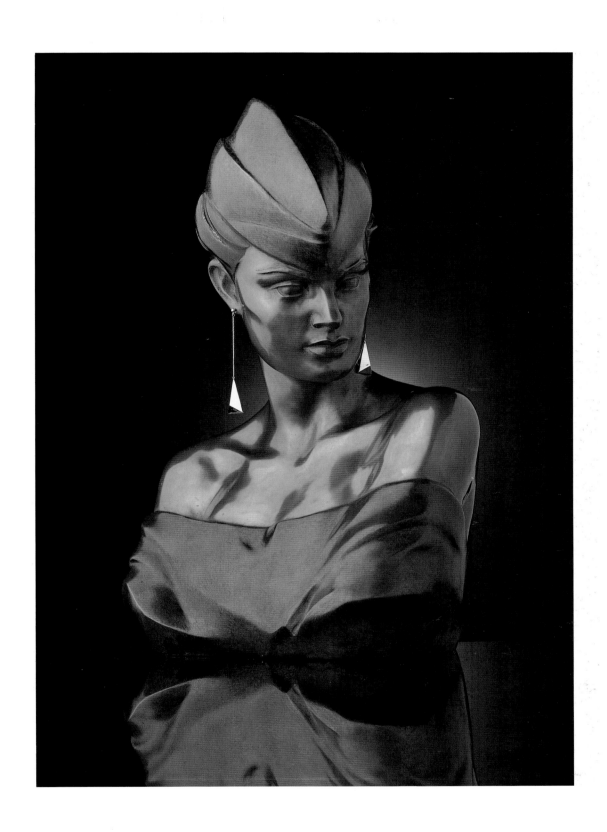

Bust
Bronze, silver, multicolored patina

Kristen
Acrylic on canvas

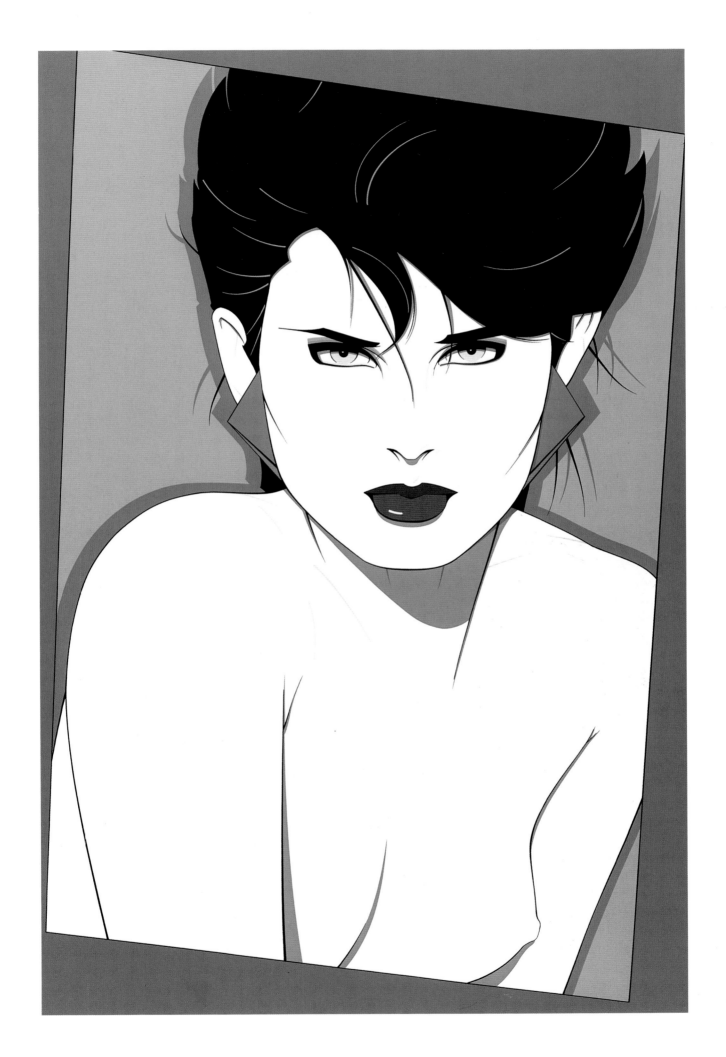

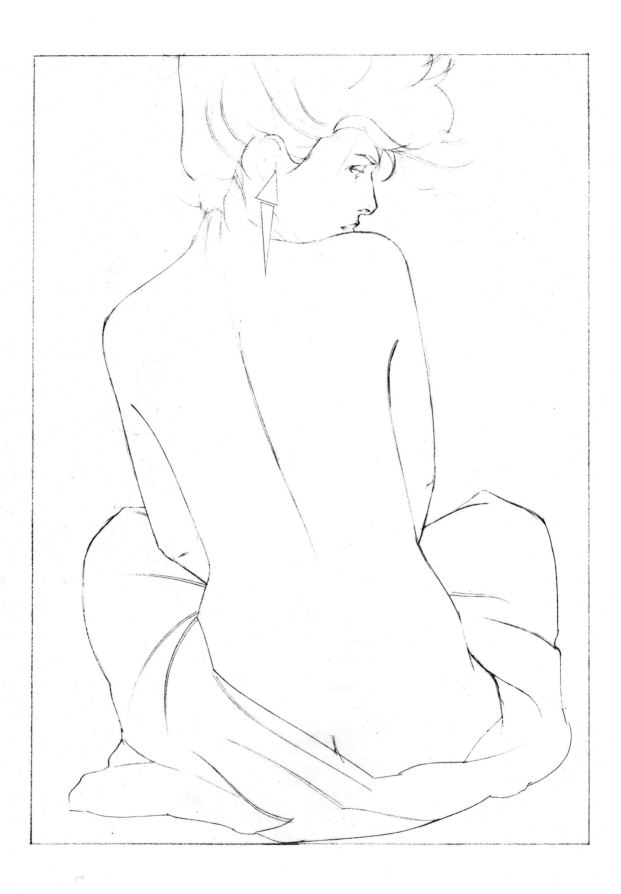

Playboy Thirtieth Anniversary
Drawing

Playboy Thirtieth Anniversary
Acrylic on canvas

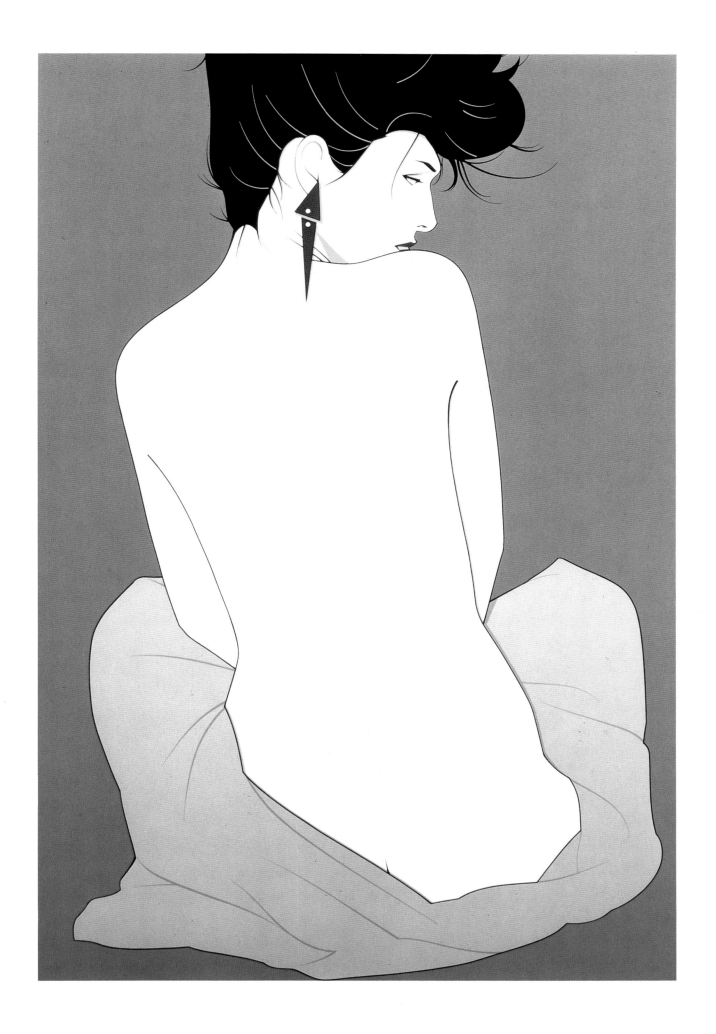

The Graphic Works of Patrick Nagel
1977-1985

Limited-Edition Graphics
Limited-Edition Posters
Future Nagel Commemorative Posters

Published by Mirage Editions
Santa Monica, California

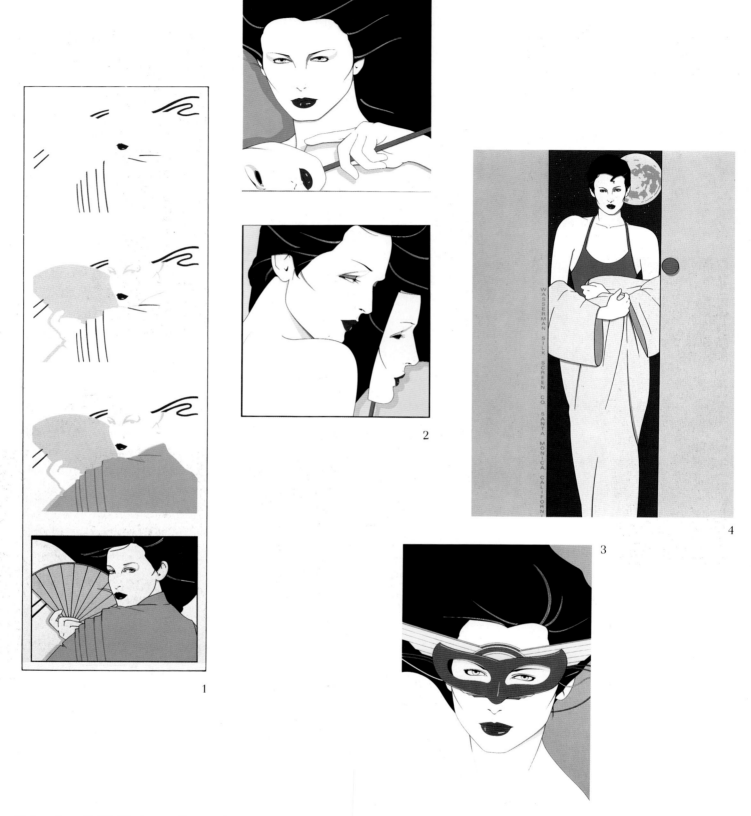

Limited-Edition Graphics

1. *Grunwald Center for the Graphic Arts.* Serigraph (progressive set), four colors, 4/80. 1100 s-i-s, 72 s/n, 10 special proofs (s/n). Size 5⅝" x 7". **2.** *Diptych.* Serigraph, nine colors, 5/80. 250 s/n, 30 signed artist's proofs. 19¾" x 20¾" each. **3.** *Mask.* Serigraph, six colors, 7/80. 50 s/n, 10 signed artist's proofs, 40" x 29½". **4.** *Standing Lady.* Serigraph, 10 colors, 8/80. 25 s/n, five signed artist's proofs. 37" x 60".

5

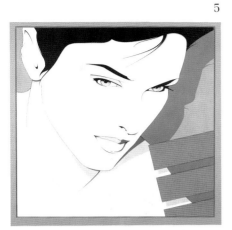

6

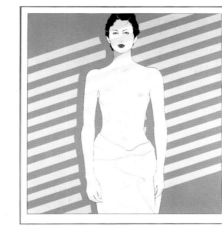

7

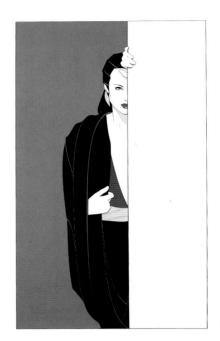

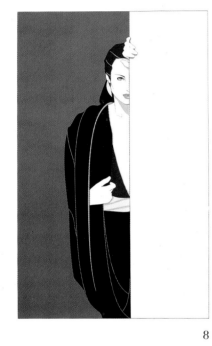

8

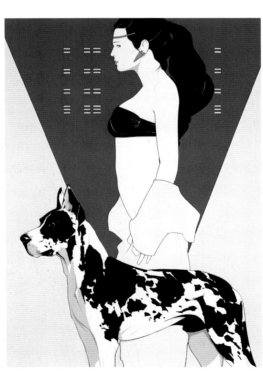

10

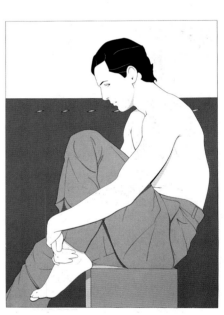

9

5. *Invitation.* Serigraph, six colors. 11/80. 30 s/n, 10 signed artist's proofs. 26″ x 26″. **6.** *Venetian Blinds.* Serigraph, six colors, 2/81. 50 s/n, 10 signed artist's proofs. 38″ x 41″. **7.** *Black Robe.* Serigraph, eight colors, 6/81. 90 s/n, 15 signed artist's proofs, five printer's proofs (s/n). 42″ x 27″. **8.** *Black & White Robe.* Serigraph with hand embossment, one color plus hand embossment, 6/81. 25 s/n, five signed artist's proofs, two printer's proofs (s/n). 32¼ x 21″. **9.** *Seated Man.* Serigraph, eight colors, 7/81. 40 s/n, 10 signed artist's proofs. 30″ x 40″. **10.** *Great Dame.* Serigraph, eight colors, 10/81. 60 s/n, 20 signed artist's proofs, four printer's proofs (s/n). 48″ x 35 ″.

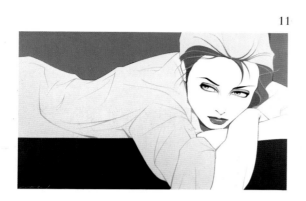

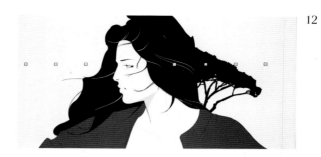

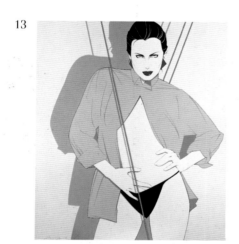

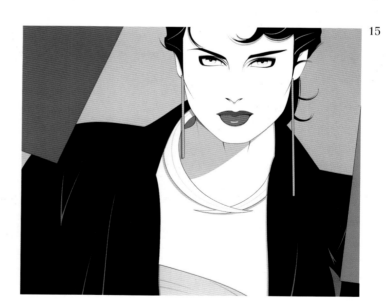

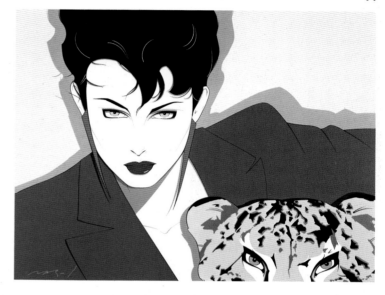

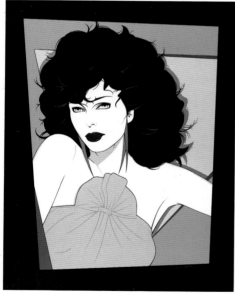

11. *Gray Lady.* Serigraph nine colors, 3/82. 90 s/n, 15 signed artist's proofs, 34⅛″ x 50⅛″. **12.** *Collectors Gallery.* Serigraph, seven colors, 4/82. 130 s/n. 29½″ x 60″. **13.** *Lori.* Serigraph, 11 colors, 7/82. 90 s/n, 15 signed artist's proofs, three printer's proofs (s/n). 36″ x 29½″. **14.** *Cheetah.* Serigraph, 12 colors, 10/82. 90 s/n, 20 signed artist's proofs, three printer's proofs (s/n). 36½″ x 46″. **15.** *Michelle.* Serigraph, 15 colors, 12/82. 90 s/n, 20 signed artist's proofs, three printer's proofs (s/n). 36″ x 41¾″. **16.** *Joan Collins.* Serigraph, 12 colors, 12/82. 150 s/n, 30 signed artist's proofs, five printer's proofs (s/n). 36″ x 28″.

s/n = signed and numbered
s-i-s = signature in screen

19

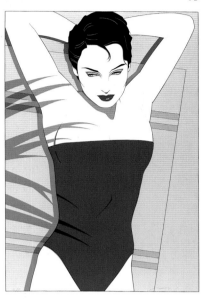

17

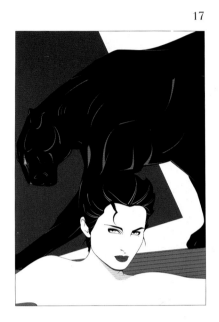

21

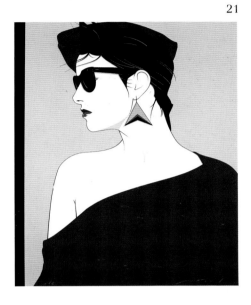

20

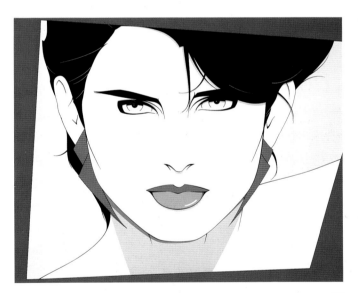

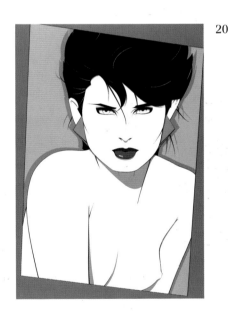

18

17. *Dyansen Special Edition.* Serigraph, nine colors, 4/83. 75 s/n, 20 signed artist's proofs, three printer's proofs (s/n). 42½″ x 30″.
18. *Cleo.* Serigraph, nine colors, 7/83. 90 s/n, 15 signed artist's proofs, three printer's proofs (s/n). 36½″ x 42″. **19.** *Heidi.* Serigraph, 13 colors, 10/83. 90 s/n, 25 signed artist's proofs, three printer's proofs (s/n). 25″ x 35½″. **20.** *Kristen.* Serigraph, nine colors, 10/83. 95 s/n, 20 signed artist's proofs, five printer's proofs (s/n). 25″ x 35½″. **21.** *Carol.* Serigraph, 10 colors, 1/84. 125 s/n, 25 signed artist's proofs, three printer's proofs (s/n). 30″ x 36″.

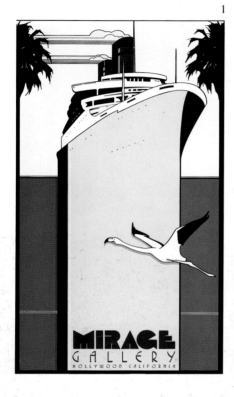

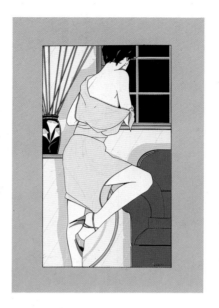

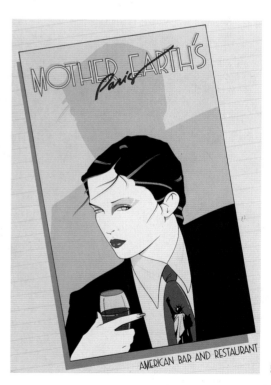

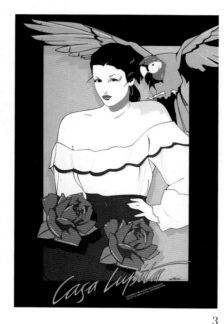

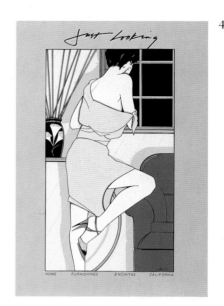

Limited-Edition Posters

1. *Mirage* (Ship). Serigraph, seven colors, 8/77. 800 s-i-s, 200 s/n. 26″ x 15½″. **2.** *Iowa Agronomics.* Serigraph 1000 s-i-s, 250 s/n, 15 signed artist's proofs; double images: five s-i-s, six s/n. 25″ x 15″. **3.** *Casa Lupita.* Serigraph, 11 colors, 6/78. 1000 s-i-s, 250 s/n, 20 signed artist's proofs, two progressive sets (s/n); double images: five s-i-s, five s/n. 25″ x 17″. **4.** *Just Looking.* Serigraph, eight colors, 11/78. 1000 s-i-s, 250 s/n, 20 signed artist's proofs, 40 state proofs (s/n, without type), two progressive sets (s/n). 25″ x 117″. **5.** *Mother Earth's, Paris.* Serigraph, seven colors, 3/79. 1000 s-i-s, 250 s/n, 20 signed artist's proofs. 25″ x 17″.

s/n = signed and numbered
s-i-s = signature in screen

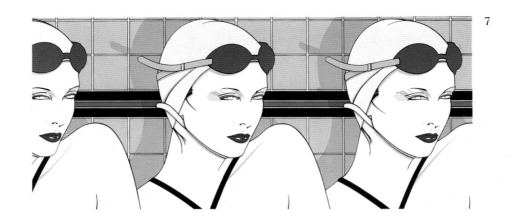

7

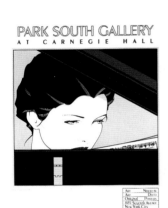

8

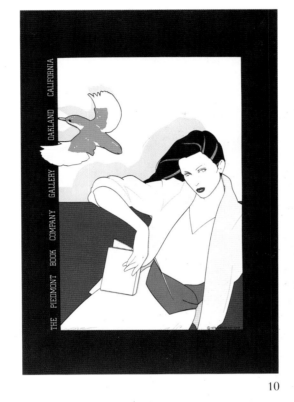

10

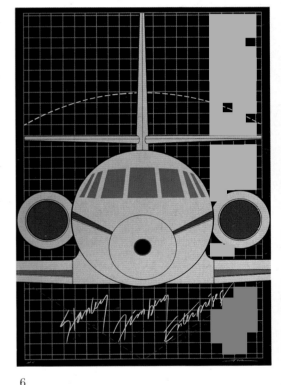

6

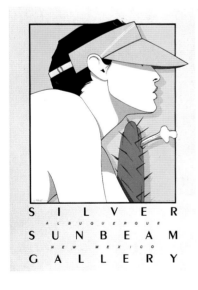

9

6. *Stanley Fimberg.* Serigraph, seven colors, 5/79. 1000 s-i-s, 250 s/n, 20 signed artist's proofs; double images: 12 s-i-s, 10 s/n. 25″ x 17″.
7. *Swimmers.* Serigraph, eight colors, 7/79. 1000 s-i-s, 250 s/n, 40 signed artist's proofs, one progressive set (s/n); double images: three s-i-s, 10 s/n. 25″ x 17″. **8.** *Park South Gallery at Carnegie Hall.* Serigraph, seven colors, 9/79. 1000 s-i-s, 250 s/n, 25 signed artist's proofs; double images: four s-i-s, six s/n. 25″ x 17″. **9.** *Silver Sunbeam.* Serigraph, nine colors, 10/79. 1000 s-i-s, 250 s/n, 30 signed artist's proofs. 10 *hors de commerce;* double images: seven s-i-s, six s/n. 25″ x 17″. **10.** *Piedmont Book Co. Gallery.* Serigraph, eight colors, 1/80. 1000 s-i-s, 250 s/n, 30 signed artist's proofs, one progressive set (s/n); double images: seven s-i-s, six s/n.

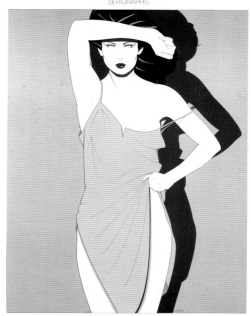

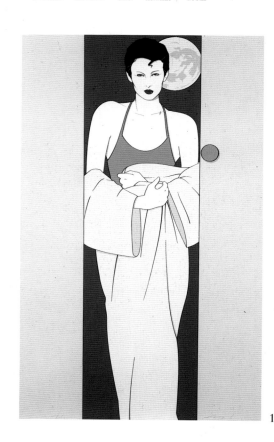

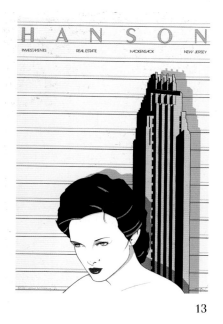

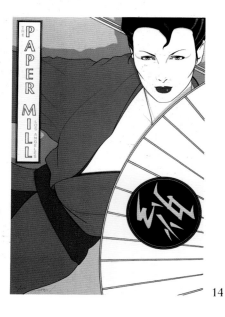

11. *Art Expo New York 1980.* Solid-plate lithograph, five colors, 2/80. 275 s/n, 30 signed artist's proofs. 33″ x 22″. **12.** *Grunwald Center for the Graphic Arts.* Serigraph, eight colors, 3/80. 1000 s-i-s, 250 s/n, 20 signed artist's proofs, 1 progressive set (s/n); double images: five s-i-s, five s/n. 25″ x 17″. **13.** *Hanson.* Serigraph, eight colors, 5/80. 1000 s-i-s, 250 s/n, 15 signed artist's proofs, 1 progressive set (s/n); double images: four s-i-s, four s/n. 25″ x 17″. **14.** *Paper Mill.* Serigraph, six colors, 6/80. 1000 s-i-s, 250 s/n, 15 signed artist's proofs, five printer's proofs (s/n); double images: five s-i-s, five s/n. 25¼″ x 17″. **15.** *Wasserman Silkscreen.* Serigraph, 10 colors, 12/80. 1000 s-i-s, 250 s/n, 20 signed artist's proofs, six printer's proofs (s/n), six double images (s/n). 25″ x 17″.

s/n = signed and numbered
s-i-s = signature in screen

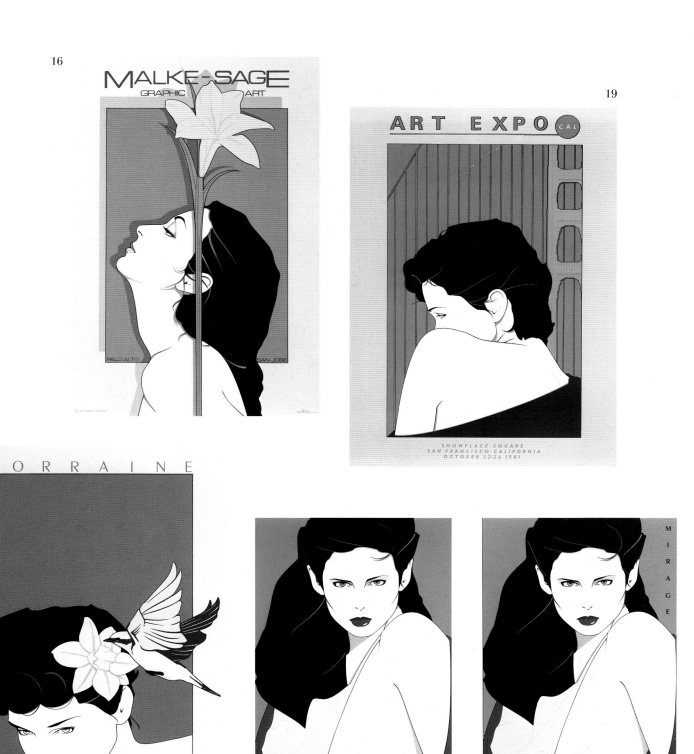

16. *Malke-Sage Graphic Art.* Serigraph, 11 colors, 2/81. 1000 s-i-s, 250 s/n, 40 signed artist's proofs; double images: six s-i-s, six s/n.
17. *Lorraine.* Serigraph, seven colors, 8/81. 1000 s-i-s, 250 s/n, 40 signed artist's proofs. 25″ x 17″. **18.** *Mirage.* Serigraph, seven colors, 9/81. 1200 s-i-s, 250 s/n, 40 signed artist's proofs, 40 special proofs (s/n, without type). 17″ x 25⅜″ each. **19.** *Art Expo Cal.* Solid-plate lithograph, 10 colors, 9/81. 275 s/n, 40 signed artist's proofs. 27¼″ x 20¼″.

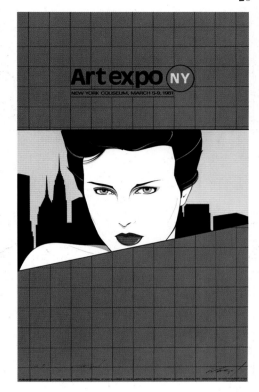

20

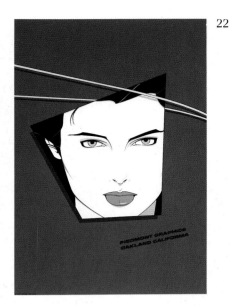

22

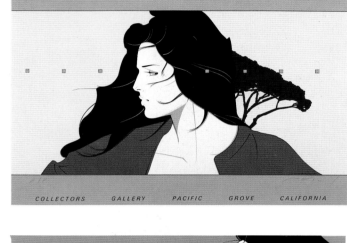

23

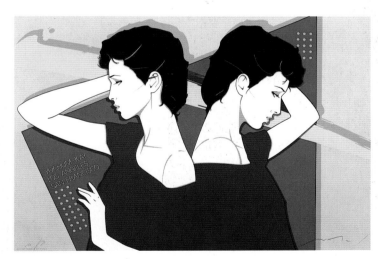

21

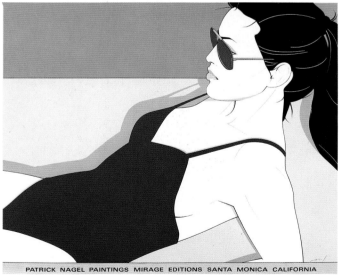

24

20. *New York Art Expo 1981.* Solid-plate lithograph, 10 colors, 9/81. 275 s/n, 40 signed artist's proofs. 28″ x 17″. **21.** *Yochum/Kay.* Serigraph, 12 colors, 12/81. 1200 s-i-s. 250 s/n, 30 signed artist's proofs. 17″ x 25″. **22.** *Piedmont Graphics.* Serigraph, seven colors, 1/82. 1200 s-i-s, 250 s/n, 40 signed artist's proofs. 25″ x 17″. **23.** *Collectors Gallery.* Serigraph, seven colors, 3/82. 1150 s-i-s, 250 s/n, 40 signed artist's proofs. 25″ x 17″. **24.** *Shades.* Serigraph, 11 colors, 4/82. 250 s/n, 40 signed artist's proofs, three printer's proofs (s/n). 25¼″ x 30⅜″.

s/n = signed and numbered
s-i-s = signature in screen

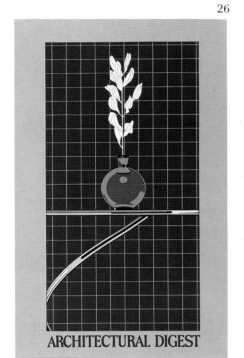

26

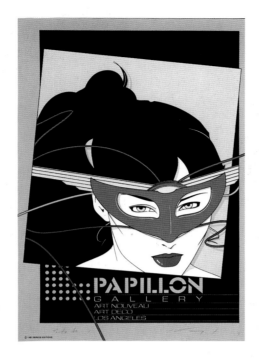

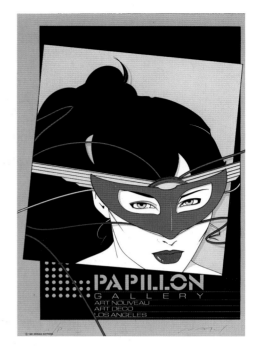

25

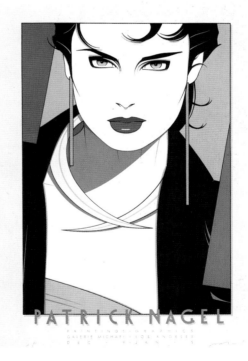

28

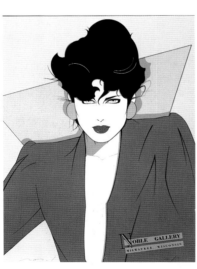

27

25. *Papillon.* Serigraph, six colors, 6/82. 1000 s-i-s, 250 s/n, 20 signed artist's proofs, state edition of 25 (s/n, with star and hand painting). 25″ x 17″ each. **26.** *Architectural Digest* (Cytisus). Serigraph, eight colors, 6/82. 350 s/n, 1250 s-i-s. 25¼″ x 15″. **27.** *Noble.* Serigraph, 11 colors, 10/82. 1200 s-i-s, 250 s/n, 40 signed artist's proofs, three printer's proofs (s/n). 16″ x 21″. **28.** *Galerie Michael.* Serigraph, 14 colors, 12/82. 1200 s-i-s, 250 s/n, 40 signed artist's proofs, three printer's proofs (s/n). 18″ x 25″.

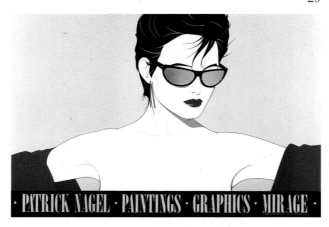

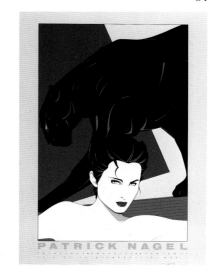

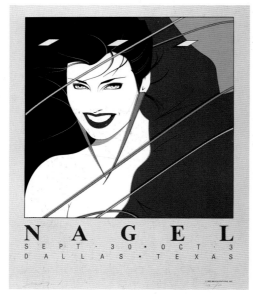

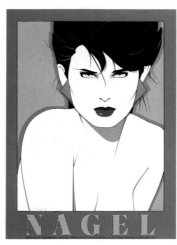

32

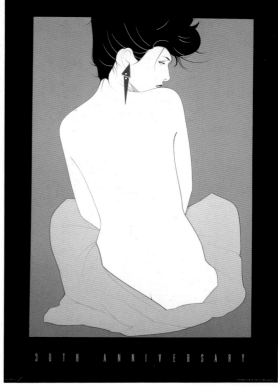

33

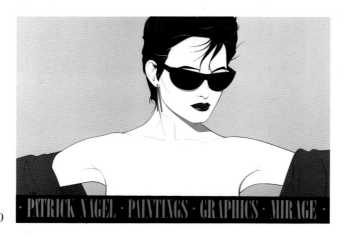

30

34

29. *Sunglasses* (Silver). Solid-plate lithograph, eight colors, 3/83, 75 s/n, 10 signed artist's proofs. 23″ x 33¾″. **30.** *Sunglasses* (Black). Solid-plate lithograph, eight colors, 3/83. 250 s/n, 20 signed artist's proofs. 23″ x 33¾″. **31.** *Dyansen 57.* Serigraph, nine colors, 3/83. 1200 s-i-s, 250 s/n, 40 signed artist's proofs, three printer's proofs (s/n). 25″ x 18″. **32.** *Nagel.* Serigraph, nine colors, 9/83. 1200 s-i-s, 250 s/n, 40 signed artist's proofs, three printer's proofs (s/n). 18″ x 25″. **33.** *Texas.* Serigraph, 12 colors, 9/83. 1250 s-i-s, 250 s/n, 40 signed artist's proofs, three printer's proofs (s/n). 19¾ x 25¼″. **34.** *Playboy Thirtieth Anniversary.* Serigraph, 10 colors, 12/83. 2500 s-i-s, 250 s/n, 40 signed artist's proofs, three printer's proofs (s/n). 35″ x 24″.

s/n = signed and numbered
s-i-s = signature in screen

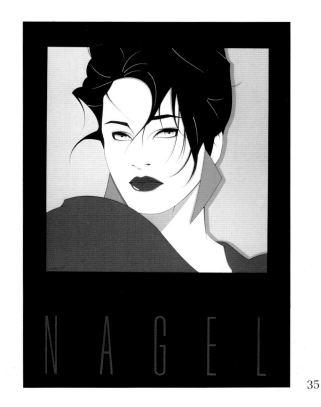

39

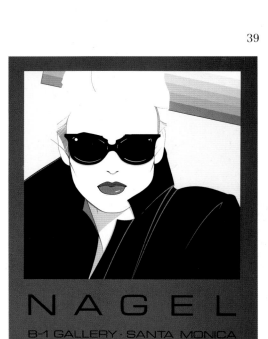

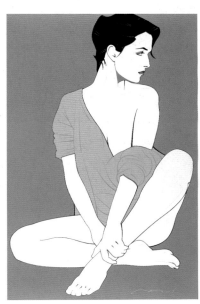

35

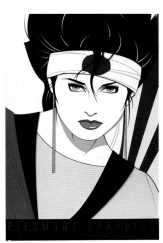

37

36

38

35. *Nagel Commemorative #1.* Serigraph, 14 colors, 4/84. 3500. 34″ x 24″. **36.** *Nagel Commemorative #2 (Palm Springs Life).* Serigraph, 12 colors, 7/84. 4000. 24″ x 34″. **37.** *Nagel Commemorative #3.* Serigraph, 14 colors, 9/84. 24″ x 36″. **38.** *Nagel Commemorative #4.* Serigraph, nine colors, 12/84. 4800. 23″ x 36″. **39.** *Nagel Commemorative #5.* Serigraph, 15 colors, 4/85. 5000. 24″ x 32″.

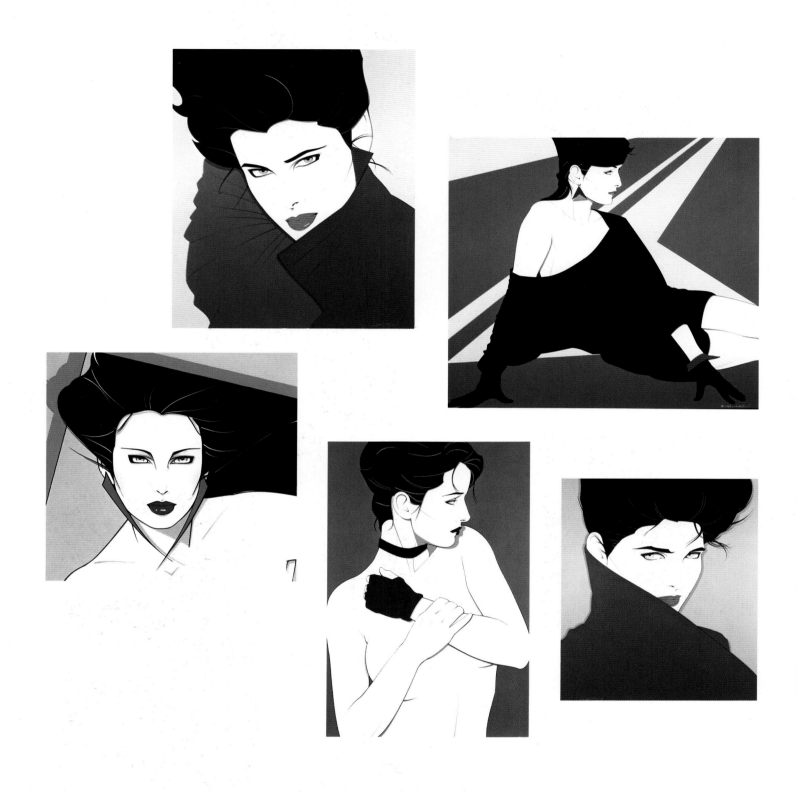

Future Nagel Commemorative Posters

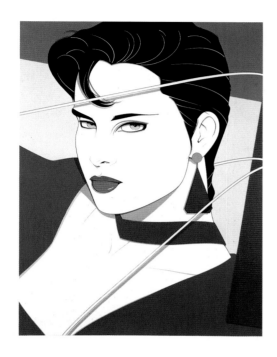
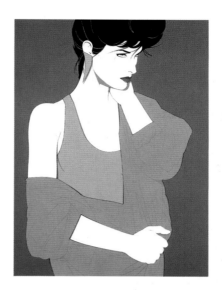
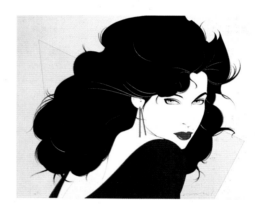
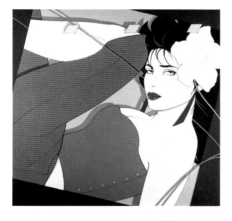
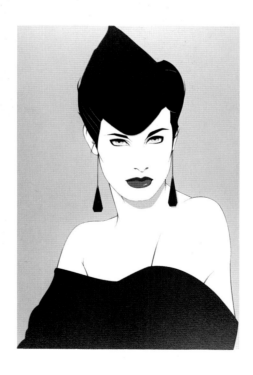
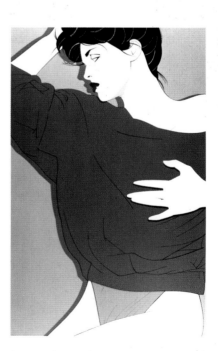